Maine NURSING

Maine
NURSING

INTERVIEWS AND HISTORY
on CARING AND COMPETENCE

Valerie Hart, Susan Henderson, Juliana L'Heureux & Ann Sossong

THE
History
PRESS

Published by The History Press
Charleston, SC
www.historypress.net

Back cover, left: Nurse with toddler. *Courtesy of Eastern Maine Medical Center.*

First published 2016

Manufactured in the United States

ISBN 978.1.46713.539.9

Library of Congress Control Number: 2015959412

Notice: The information in this book is true and complete to the best of our knowledge. It is offered without guarantee on the part of the authors or The History Press. The authors and The History Press disclaim all liability in connection with the use of this book.

CONTENTS

ACKNOWLEDGEMENTS

This book is dedicated to Maine nurses. In 1914, Maine nurses formed a professional association, and in 1915 they successfully advocated for legislation requiring the registration of all Maine nurses. These actions were taken to provide for standards of nursing education to promote quality nursing care. This book identifies the caring and competence of Maine nurses from this beginning in 1914 to the present, 2015.

We would like to acknowledge the research and publications of Marla Davis, MS, RN, and Martha Eastman, PhD, MS, BS, CMC, and thank them for their contributions. We acknowledge the dedication and expertise of Beth Clark, PhD, RN, in developing this book. We thank Myra Broadway, JD, MS, RN, for her editorial contributions, support and promotion of the centennial of the American Nurses Association (ANA) coming to Maine and the formation of the Maine State Board of Nursing.

We are grateful to all those who were willing to be interviewed and to those who conducted the interviews, especially students at the University of Maine and Husson University, as well as faculty member Jeanne-Ann Ouellette. We thank the talented transcriptionists, Shawn Plante, Ruth Elkin and Wendy Ledger, and those who offered to read and provide feedback on a work in progress, Millicent Higgins, Charmaine Daniels, Ellen Bridge, Leslie Nicoll and John Clark. We would also like to thank Abigail Wellman for her work on preparing our photographs and all those who shared their photographs.

Thank you to the Maine Folklife Center, University of Maine, for archiving our oral histories. We thank ANA Maine, Kappa Zeta-at-Large, Omicron

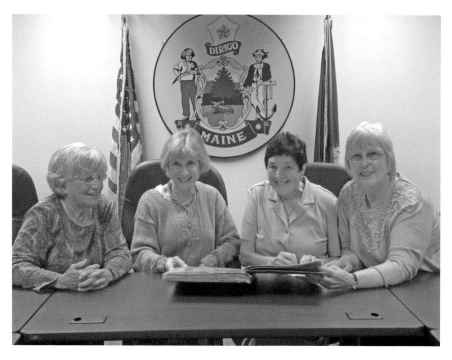

Susan Henderson, Myra Broadway, Ann Sossong and Julie L'Heureux at the Maine State Board of Nursing developing *Maine Nursing. Courtesy of Juliana L'Heureux.*

Xi Chapter-at-Large and the Maine Nursing Practice Consortium, all of which gave us gifts of financial support.

All royalties from sales of this book go to the American Nurses Foundation for the purpose of supporting Maine nursing research.

We particularly thank our editor, Mary Pelletier, MS, BS, RN, who donated her time, expertise and energy over more than two years to provide content and copy editing and support.

INTRODUCTION

Nurses are ordinary people who do extraordinary things; their recollections reveal this. *Maine Nursing: Interviews and History on Caring and Competence* is a collection of oral histories that document and preserve the wisdom and memories of nurses. Student nurses were the primary collectors of these oral histories. Dr. Ann Sossong and Dr. Beth Clark at the University of Maine–Orono had their students collect oral histories of Maine nurses as part of a course to appreciate components of leadership and to consider how past events and developments influenced the future of the nursing profession. As the centennials of the Maine State Nurses Association (2014) and the Maine State Board of Nursing (2015) approached, others joined in interviewing nurses with the goal of using their stories to write a book honoring Maine nurses and their contributions to society.

This book contains selected stories of Maine's nursing heroes. There were many nurses who were never interviewed. There were many more interviews of nurses who made significant contributions that were not included. Many stories were not used in their entirety, and only portions of people's accomplishments have been included. These few stories are intended to honor all nurses and are tributes to Maine's past nurses and leaders whose expert and compassionate care guide our path into the future.

As early as 1797, Marguerite-Blanche Thibodeau Cyr, affectionately known as "Tante Blanche," provided care for the French settlers in

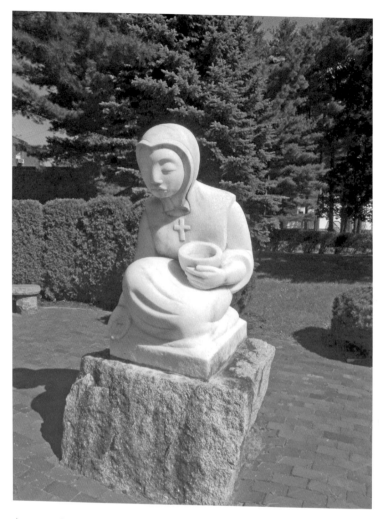

A statue of the Gray Nuns, Sisters of Charity, Saint Mary's Hospital. *Courtesy of Saint Mary's Medical Center.*

Madawaska in northern Maine during the "black famine" and was recognized as the "savior of her people." At that time, Cyr instinctively employed public health techniques when she inventoried and allocated scarce food provisions in the community and redistributed supplies according to need.[1] During the American Civil War, letters written by Rebecca Usher (1821–1919), a nurse from Hollis, Maine, who cared for soldiers in several hospitals, described her love of nursing: "I am delighted with hospital life; I feel like a bird in the air or a fish in the sea,

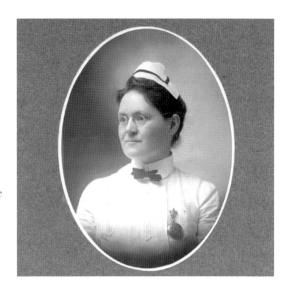

Right: Vintage portrait of a Maine General nurse, Portland. *Courtesy of Maine Medical Center (MMC).*

Below: Ward A, Maine General, Portland, early 1900s. *Courtesy of MMC.*

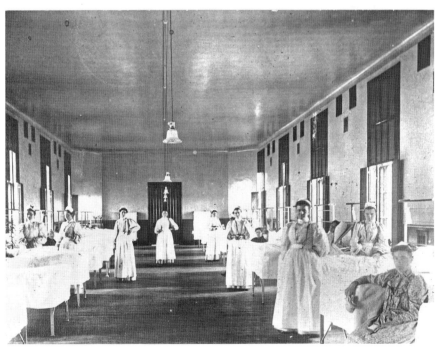

as if I had found my native element."[2] In Lewiston, *les Sœurs Grises*—"the Grey Nuns"—arrived at the city's Grand Trunk Station from Montreal in the 1870s to set about providing healthcare and social services support for thousands of immigrant workers who were employed in the mills

along the Androscoggin River.[3] Many women participated in building compassionate care before the development of professional nursing. Their work became the foundation of nursing practices that the public recognized as the basis for the most trusted profession.

Chapter 1

BUILDING FOUNDATIONS
OF A PROFESSION

1914–1919

Nursing care was based on compassion, justice and social reform by early nursing leaders.[4] The period from 1890 to 1920 was known as the Progressive Era, during which political and social reforms were needed to serve growing populations and diverse communities. As the Industrial Revolution intensified, Americans moved from farms into cities to work in factories, and immigration increased. Conditions in tenements around factories were overcrowded. Factory workers, including children, often toiled long hours in unsafe workplaces. In the urban areas, unhealthy conditions and lack of support systems resulted in the need for more care to be provided in institutions.

For most of the 1800s, hospitals were unsanitary places staffed with few informed caregivers. Concern about patient safety was "the primary goal underlying the adoption of formal nursing in the United States."[5] Florence Nightingale, the founder of modern nursing, established the Nightingale School for Nursing at Saint Thomas Hospital in London in 1860. She had saved thousands of lives in the Crimean War in the 1850s because she recognized the importance of sanitation and good ventilation. During the Civil War, Nightingale was an advisor to the United States Sanitary Commission, whose mission was to establish conditions conducive to health in military camps and hospitals. A committee from the commission visited New York's Bellevue Hospital; its report of this visit reflected abysmal conditions and unsafe patient care. This report influenced Bellevue Hospital

to open the first training school for nurses in America, based on Nightingale's model, in 1873.[6]

As the number of hospital training schools around the nation grew rapidly, problems included lack of program admission standards, exploitation of students as workers and lack of opportunity for adequate clinical education.[7] Nursing leaders identified the need for standards of nursing education and for laws to protect the public. This awareness led to the development, in the 1890s, of two organizations that later became the American Nurses Association (ANA) and the National League for Nursing (NLN). By 1903, North Carolina had become the first state to pass laws related to the registration of nurses, followed by New York, New Jersey and Virginia.[8]

A nurse of the first graduating class of Central Maine Medical Center, 1893. *Courtesy of CMMC.*

The development of nurse training in Maine followed national patterns of large and small hospitals creating training schools for nurses. Mabel Hammons, a graduate of the Eastern Maine General class of 1899, stated: "In 1897–99, graduate nurses were capable of going into a home; making a room surgically clean; preparing a patient for operation, even for abdominal surgery; administering ether anesthesia by drop method; giving nursing care, post-op, for two or three weeks. Cash compensation $18 per week. So far as I know, we never lost a case."[9]

Registration of Maine Nurses

Maine nurses participated with the American Nurses Association (ANA) to develop standards of education and to promote legislation for the registration of nurses. At a meeting of the Maine General Alumnae Association in 1908, participants discussed forming a state nursing association. The Maine State Nurses Association (MSNA) was incorporated on December 10, 1914. Edith L. Soule, superintendent of the Children's Hospital in Portland, was elected the first president. The

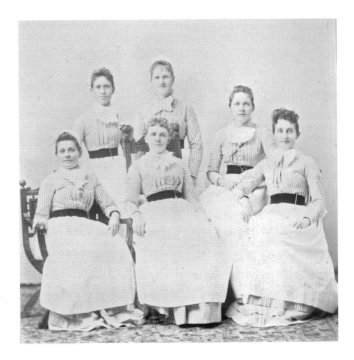

The beginning of a profession: Maine General graduates, 1890s. *Courtesy of MMC.*

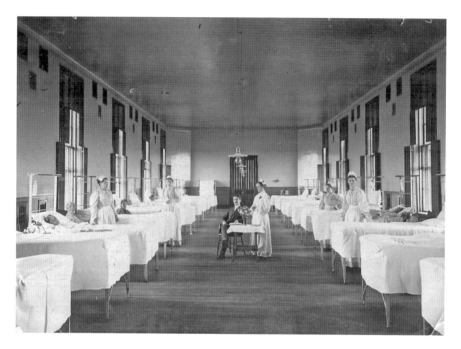

A Maine General ward. Edith Soule is the second nurse on the right. *Courtesy of Hobbs Collection, South Portland Historical Society.*

newly organized MSNA advanced a proposal for a bill to register nurses. The bill for state examination and registration of nurses passed in the state legislature and was signed into law on March 18, 1915.[10] Each nurse who was registered received a pin with a picture of a pine tree and the words "registered nurse" on the front side and the nurse's registration number on the back side. Speaking of the work of its legislative committee, the MSNA report stated: "To this committee and Mr. C.L. Andrews of Augusta, we are indebted for the passage of a bill which we feel compares very favorably with bills in other states and will result in much good both to the nurses and to the public."[11] MSNA's curriculum committee proposed a curriculum that set a minimum standard for a two-year hospital course; this proposal was adopted.[12] Thus, by 1915, Maine nurses had formed the Maine State Nurses Association as a part of the ANA and had begun the work to protect the health of Maine people and to develop the profession of nursing.

PUBLIC HEALTH NURSING

In her 2006 doctoral dissertation, Martha Eastman discussed the epidemics of smallpox, diphtheria, scarlet fever and other infectious diseases in the late 1800s and early 1900s. She described the difficult processes of isolation, fumigation and disinfection used on patients with infections as they either died or recovered. In Maine, seaports provided a challenging environment when a ship came in with smallpox cases on board. Eastman described the practice of scrubbing those infected with the disease before they were allowed in public. When the patients' rashes were almost gone, they were bathed with soap and water, rinsed and then scrubbed with a solution of corrosive sublimate before being dressed in disinfected clothes. When there was smallpox in the logging camps, it was the practice for a person—often a man called a nurse (regardless of his training)—to travel to the camps, usually by canoe, to disinfect, fumigate and scrub the loggers.[13]

Tuberculosis (TB) was a leading cause of death in the early part of the twentieth century. Both state and voluntary organizations played a role in working for public health. Some nurses worked through the Red Cross and others through the Maine Anti-Tuberculosis Association.[14] There were efforts by state and voluntary groups to increase education and treatment of TB.

The Maine Anti-Tuberculosis Association of Piscataquis County and Dexter opened a dispensary in Milo in 1915. Clarissa Johnson, a nurse who graduated from Presbyterian Hospital in New York City and worked at a settlement house in Boston before coming to Maine, was hired to staff the dispensary, visit homes and promote health. In an article published in the *Piscataquis Observer* on health topics, Johnson wrote:

> *The only reason that the nurse's work has developed into such broad lines of social service is the fact that she has the privilege of entering the homes. She comes in working dress and is very willing to give a bath, make a bed, change a dressing, or render some other service, which can be interpreted in terms of friendliness. This service is actual to the patient and family. Other problems besides sickness meet her on every threshold—lack of employment, delinquency in children or adults, bad sanitation, poverty and ignorance in every form. The public health nurse cannot help being a social service worker, for in recognizing her responsibility toward the family health, she must also regard the family as a part of the community, and therefore sees the civic aspect of her work and becomes a social part of the health campaign.*[15]

The role of the public health nurse required sensitivity, empathy and the ability to communicate across cultural and economic lines. Providing education acceptable to families was critical. Sometimes it became necessary to remove children from homes. The early public health nurses needed to work to win and maintain cooperation of all community members, including physicians.[16]

WORLD WAR I

The Red Cross Nursing Service was established by the Nurses' Associated Alumnae and the Red Cross in 1909. Red Cross enrollment was accepted by the War Department as a reserve for the Army and Navy Nurse Corps for service in World War I (1914–18), in which twenty million people died.[17]

Ruth Weeks Henry, a 1914 graduate of the New England Deaconess Training School for Nurses in Boston, later initiated the Red Cross home health program in Bath, Maine. Henry was one of sixty-five nurses of the Harvard Unit that, under the leadership of Harvey Cushing, MD,

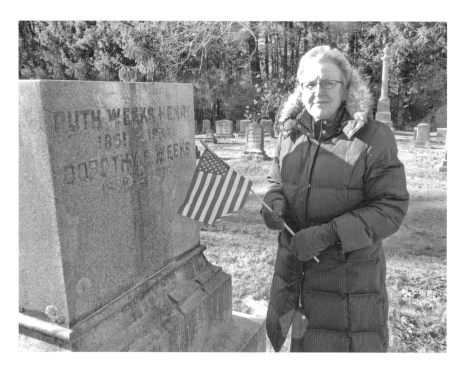

Marla Davis at Ruth Weeks Henry's grave. *Courtesy of Juliana L'Heureux.*

became part of the staff of Base Hospital No. 5 in France. This group was considered to be "the first (Americans) in France," arriving a full year before American troops. Its first job was to replace exhausted British hospital staff in Dannes-Camiers for six months and then in Bologne for fourteen months. Both groups cared for massive numbers of patients with head injuries, gas poisoning, trench fever, shell shock and self-inflicted wounds. Patient and staff casualties also resulted from enemy bombing.[18]

The organizational structure of nurses in military service in that period had its own challenges. The nurses began their wartime service affiliated with the Red Cross but were militarized to aid their deployment and movement. Although their Army Nurse Corps assignments included the supervision of enlisted corpsmen, nurses were not commissioned officers; this lack of authority led to considerable tension. Nursing leaders and women's rights activists campaigned for recognition of nurse leadership and in 1920 won "relative rank," which was described as quasi-officer status.[19]

INFLUENZA OUTBREAK

A flu pandemic spread across the world in 1918, taking an additional twenty-seven million lives worldwide. In Maine, Bath was particularly affected due to maritime activity; approximately 2,320 cases and fifty-five deaths were reported. Three nurses—Harriet Bliss, Alice Dain and Adelaide Hogue—lost their lives caring for flu victims in temporary quarters around the city.[20] Mercy Hospital in Portland started as Queens Hospital at the corner of State and Congress Streets in 1918 by the Sisters of Mercy to treat the flu victims.[21] Mary Catherine Ragan described what she remembered about the flu outbreak:

> *I graduated in 1942 from the Queens; it was a small hospital. Flu was severe in Maine. We had friends that lived in a three-flatter. There was a death on the first, second and third floors. It was all the same family. I don't remember the flu, but I do remember the way they talked about it. In fact, there were no public gatherings. Near Queens Hospital is Saint Dominic's Church. They couldn't have a Mass inside, so the priest said Mass on the top of the stairs, and the people were out on Gray Street, listening. My mother and father attended that because we lived nearby.*

From 1900 to 1920, Maine nurses worked in homes, hospitals and communities and served on battlefields to provide knowledgeable and compassionate care:

> *It is significant to note that modern nursing began to develop during a period when social, economic and industrial problems were colossal, and interest in the humane treatment of individuals was high. In adapting to demands for health care, pioneer nurses began to express concern for the specific needs of the sick. This was and is nursing's unique contribution to health care.*[22]

Chapter 2

NURSING AFTER WORLD WAR I AND THE GREAT DEPRESSION

1920–1939

The nation began to recover from the significant losses of World War I. Approximately three hundred American nurses died in World War I; one hundred of them were buried in France.[23] The ANA worked to have the Florence Nightingale School for Nursing in Bordeaux, France, established as a memorial to American nurses. Several nursing organizations raised funds to contribute to the completion of the school. Minutes of a 1920 MSNA meeting recorded its support of the project: "Resolved that the new building for the school of nursing at Bordeaux, France as a fitting tribute to our American nurses who gave their lives in the service and present a most appropriate opportunity for the members of our association to show its respect to the nurses who so willingly gave their lives for democracy."[24]

The postwar years brought many changes. After years of hard and often dangerous work by women, the Nineteenth Amendment to the United States Constitution was ratified in 1920. The amendment granted women the right to vote and run for elected office. The availability of consumer goods in the United States rose to never-before-known levels. Electricity, telephones, radios, motion pictures, affordable cars and air travel became available. Yet "only one of ten farms had electrical power and seventy-five percent of rural families had no indoor plumbing."[25] In the '20s, there was great faith in business and in the belief that "invention, not political reform, was bringing the utopia of humane capitalism."[26]

When the stock market crashed in the fall of 1929, there were no safety nets in place for institutions or individuals. Investors lost "as much money in October, 1929 as the US had spent fighting in World War I. By 1932, between one quarter and one third of all American workers were unemployed...By 1933, a quarter of all the nation's farmers had lost their land."[27]

DEVELOPMENT OF NURSING EDUCATION

During the 1920s, infectious diseases continued to be a major cause of morbidity and mortality. Hospitals began to use oxygen tents, and the iron lung was developed. Until the discovery of insulin, most patients with the diagnosis of diabetes died. In 1922, insulin was first tried on a fourteen-year-old boy with successful results. Sulfonamides were discovered in 1935. The *50th Anniversary Report* of the MSNA noted the "steadfastness of purpose and courage of nurses...who cared for patients during the mid 1930s typhoid epidemic."[28]

Many nurses had been trained, but "unfortunately, too many of these nurses were inadequately trained. Few nurses were prepared to take on the role of health promotion and teaching."[29] The Maine State Department of Health formed the Division of Public Health Nursing and Child Hygiene in 1920. Edith Soule was named the first state public health nursing director.[30] In 1922, when the department developed Maternal and Infant Hygiene Services, Soule "found few nurses had the training and experience for the job."[31] Because Washington and Aroostook Counties had the highest maternal and infant mortality rates, the department started its health promotion work there. Nora Rowell, a graduate of Central Maine General School of Nursing who had taken a Simmons College postgraduate public health course, was hired to be the public health nurse for Washington County. Rowell assessed the condition of drinking water and milk and investigated factory working conditions. She visited homes, spoke with mothers and physicians, collected data on infant and maternal mortality and sent morbidity data to the state. She observed that, for Washington County, the nearest hospitals were in Calais or Bangor. There were few midwives, and most of the births took place at home with untrained attendants. Few patients received prenatal care. There were few clinics available to both mothers and babies. Rowell initiated the effort to document and advocate for nursing services in the home, particularly in rural communities.[32]

In 1923, the Winslow-Goldmark Report, funded by the Rockefeller Foundation and produced by the Committee for the Study of Nursing Education, identified inadequacies of nursing education; moreover, the Personnel Classification Board of the federal government did not list nursing as a profession due to educational inequities.[33] In response, the ANA conducted an analysis of practice, education and the distribution of nurses. It also identified ethical precepts of practice while seeking professional status for nursing.[34]

The following stories of Maine nurses depict examples of nursing education, developing technology and the health concerns of this era.

Emily Floyd entered the Maine General School of Nursing in Portland in 1930. One of nine children, her home was on a farm in Coburn, New Hampshire. Floyd said that she always knew she did not want to be a teacher; she wanted to be a nurse. The Depression did not have a major impact on her family. "We never had a whole lot," she said. She came to Maine General because a local physician recommended the program. She did not recall the tuition, but as a student, she was paid a small stipend by the hospital. Initially, she was homesick: "From a farm in New Hampshire, it was something to get so far away." She had a roommate and lived in a nurses' residence near the hospital. She recalled the students marching through the hospital in their uniforms and caps singing Christmas carols on Christmas Eve.

When Floyd was asked to share a significant experience, she described caring for young men who could not move. They had polio and were isolated, with three to four patients in the room. She recalled having to feed them and do all of their care. As their care was described, it became apparent that the men were in tank respirators called "the Drinkers," or iron lungs, which were developed in the late 1920s.

While in nursing school, Floyd met a resident who later became her husband. After graduation, she worked as a head nurse. Then she married and went to Boston with her husband. After his training, the family moved to Farmington, Maine, where they raised their children, and he became the first ophthalmologist in the area. Floyd assisted her husband with surgical procedures at the Farmington hospital.

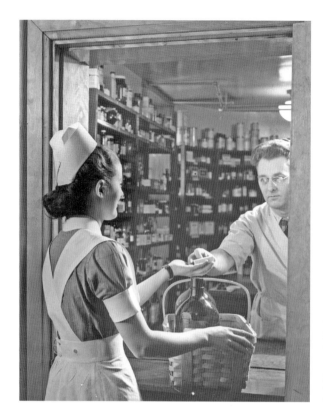

Left: A student at a pharmacy, 1930. *Courtesy of CMMC.*

Below: A hospital laboratory, 1930s. *Courtesy of CMMC.*

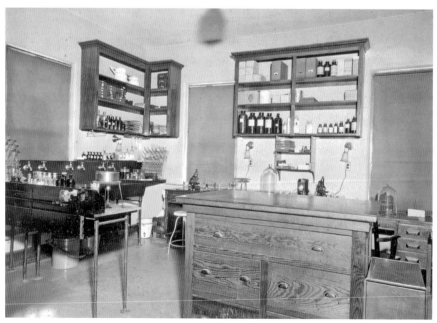

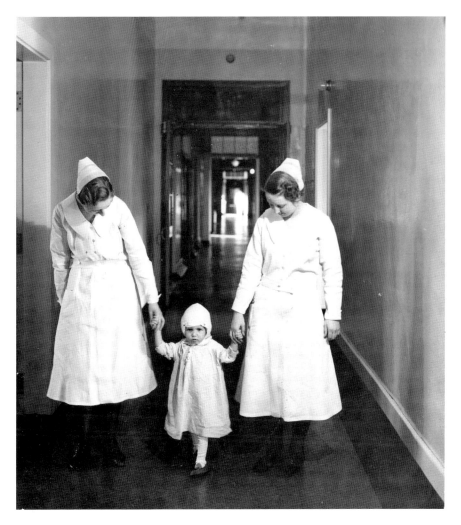

Nurses with a child, 1930s. *Courtesy of MMC.*

In 1935, Alice Williams graduated from Eastern Maine General Hospital School of Nursing. She grew up in Addison, in Washington County. When she was asked why she chose to become a nurse, she said:

> *I'm happy I was a nurse. I didn't plan to be. I was quite good at mathematics, and I thought I wanted to go to business school. I had a friend that lived down the street from me, and she wanted to be a nurse.*

She was after me all the time: "Come and go in training with me." "No, I think I'll go to business school." I had my trunk, I had my place to live in Bangor, I had all my new clothes to go to school and my mother was away. My brother came home. He was married, and he had graduated from the University of Maine...I got supper; we sat there, and my father said, "Alice is going away in a couple of days to Bangor to business school." And my brother said, "Oh, that's ridiculous. Why would she want to do anything so stupid?" He continued, "My wife graduated from business school; she can't get a job anywhere." And I didn't say anything. I did the dishes up. I went down to my friend Helen's, and I said, "I think I'll go in training with you." Father took us up to Bangor. My mother gave me a fifty-dollar bill and said you may have to buy something. The first fifty-dollar bill I ever saw...They made you pay for uniforms, and they had to send to New York to get them. I was the only one that was in street clothes for a couple months until my uniforms came. But we didn't go on the floors anyway.

Williams said she had not thought much about how the Depression affected her family:

My father was a blacksmith and was very busy. He had a great big garden. We had a cow, a pig, hens and a cellar full of all kinds of food from his garden—apples, strawberries, blueberries and raspberries. I never thought of it. My father put my brother through college. He graduated a year before I got out of high school.

Williams described her nursing school experience as kind of fun. "The girls were nice, and we studied hard," she said. She observed that the residence where she lived had been made into a motel, with the original tunnels that connected it to the hospital still existing:

The wards were large. There would be thirty patients on a floor, and you would have to give medications. In our hospital at that time, there would be a head nurse on the floor, and everybody else would be a student nurse except on the private floors where they [the families] *might hire someone.*

One student gave all the medications, but each student did their own treatments. Students worked from 7:00 a.m. to 7:00 p.m. We were scheduled for three hours off in the middle of the day. But you wouldn't get off because you had to clean the utility room. Cleaning the utility room included cleaning bed pans and putting them in the sterilizer in a container

heated with steam. Other equipment, such as dressing sets, irrigating sets, urinary catheters and Levine tubes, were washed and boiled in what were called "fish tanks" on a gas stove. Needles and syringes were washed and boiled every day. When you used one, you could put it back in the alcohol and use it again. Once a day, you boiled the whole works and put them in fresh alcohol...and we didn't throw away hypo needles. If they got dull, we sent them down to the carpenter shop, and they would sharpen them. The thermometers were mercury. We washed them after use, put them in bichloride mercury solution and let them set until the next time they were needed. If a student broke a thermometer, she was expected to pay for it.

Even though intravenous therapy existed, when patients needed fluids, hydration was commonly achieved by a subcutaneous injection of fluids called a clysis. A nursing text of the era describes the preparation of normal saline or glucose intravenous solutions on the unit by nurses who were cautioned to use only "freshly distilled, sterilized water, not over twenty-four hours old...The most scrupulous exactness must be exercised in the preparation of solutions for intravenous use."[35] Williams continued to describe infusion therapy: "If somebody had a transfusion or IV, we always sat with them, the whole time. Most everybody got a clysis. In those days, we could leave the patients and go back and check every so often. But the IV and transfusions, we sat with." The bottles were made of glass, and the tubing was reusable.

The hospital was in the black in those days. There was a doctor that was the head of the hospital. I happened to be a night nurse, and you never knew when he might appear. If you were in the office and the light was on in the utility room, he would come down and say, "Do you need that light? If you do, all well and good...If you don't, please turn it off; electricity is expensive!"

In that era, most surgical anesthesia involved the use of ether. Postoperative nausea and vomiting were common. Williams was asked if taking care of postoperative patients was difficult. She replied, "Yes, because they didn't have recovery rooms in those days." In the operating room after surgery, "they just, when they go throw up, they put them right back on the stretcher, and an orderly and a nurse would go down to the operating room and pick them up and get them to their room as quickly as they could." On the unit, the nurse stayed right with the patient: "You never knew when they were going to throw up; most everybody threw up after the ether." The biggest danger

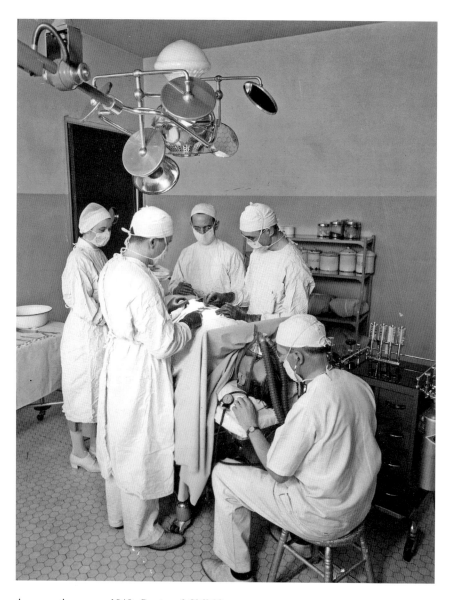

An operating room, 1940. *Courtesy of CMMC.*

was that the patient might choke, so patients were constantly monitored until they were able to maintain a clear airway. Williams continued:

> *If you went in for appendicitis, you stayed for a couple weeks. If you had a baby, it might be that long. I can remember going down to that floor where*

the expectant mothers were, and some of the poor little things were so thin and pale, and their blood would be way down. The kitchen would send up raw liver for them to eat. They'd have a whole sauce dish we'd take around to them, and those poor girls would have to eat that crap. It was supposed to jack their blood up. They couldn't have it cooked. Ohhh! It was awful! Some of them almost gagged.

I burned my hand, and I couldn't work on the wards, so they put me to work out in the pest house out of sight. They had a pest house out back, and all the patients in there had the measles. I'd never had measles, and there [were] *about six patients out there. They all had complications. Maybe they'd come in with a fracture, or pneumonia, but they had the measles. I worked out there seven to seven, and I got three extra hours credit. I worked out there for about a month until everyone was through the measles. My classmate worked nights out there. Neither of us had the measles, but then she got them, so she was a patient.*

I remember having one typhoid patient. He was a young fellow in the boys' ward, and he survived. We had a lot of TB patients. They were sent out to the TB sanitarium. We went to the TB sanitarium and affiliated for a month.

As a night nurse, I had a white, heavy-knit wool sweater. I would take it off sometimes and put it on the chair at the desk. In the morning, we had to pick up all the blankets. They just picked them up, put them on a stretcher, took them in to the linen room and put them on the shelf. There was a little Polish man from the Great Northern Paper Company, and all he had was one of our seersucker bathrobes. One morning, he got up early and went into the men's ward. He took a stretcher in there and started taking blankets off, and I noticed he had on a white sweater. He had my sweater on! He used to come out every morning and get my sweater and fold up those blankets.

I was quite healthy. I didn't have to have my appendix or tonsils out like so many of them did, and I was the first one to get through [because she had not missed required time]. *I got through long before graduation.*

After graduation, Williams worked at the hospital. She lived at the nurses' home where she had lived as a student and got meals, laundry and fourteen dollars a week.

Sister Mary Consuela White graduated from Bath High School in Bath, New Brunswick, Canada, in 1937. She then entered the Madigan Hospital School of Nursing, sponsored by the Sisters of Mercy in Houlton, Maine; graduated in 1941; and joined the convent to become a Sister of Mercy in 1944.

Sister Consuela obtained a BSN (bachelor of science in nursing) from Catholic University and an MSN (master of science) from Boston University. In addition to her multiple leadership positions in both education and administration, Sister Consuela served on the Maine State Board of Nursing, was president of the MSNA and was on numerous MSNA committees. She was a charter member of ANA-Maine. Sister Consuela founded the Department of Nursing at Saint Joseph's College (SJC) in Standish.

She was interviewed at SJC in 1991 by a member of the nursing department:

My vision was baccalaureate nursing education as a foundation for women and men who would go into professional nursing. I have long subscribed

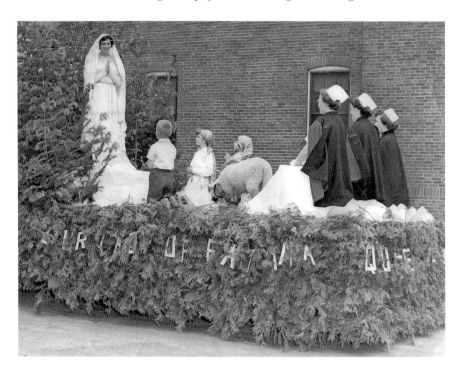

Our Lady of Fatima Parade, Houlton. *Courtesy of Houlton Regional Hospital.*

to that in my heart. As soon as I heard that there was such a thing as baccalaureate education in nursing, I felt I could grasp the value of having a broader-based education because nursing is caring by one human being for another human being. Unless one is educated, matured and cultured, all that comes with education and exposure to life and decision making, I think you don't get the most out of the talents and gifts you have as a human being.

I know that many good nurses never had an opportunity for baccalaureate education, but that doesn't mean that they were not educated through life's experiences, through association, through reading, through study and through their own reflection on their life. The vision for Saint Joseph's was that the graduate of this program would be able to go anywhere, provide quality nursing care, continue graduate education and develop intellectual abilities and humanitarianism.

Nursing school was considerably different than it is now. It was a happy time. It was a hardworking time. The hospital where I trained was a small hospital. There were only seven in our class, and we were all young women from local communities. Because the hospital was small, and because the Sisters of Mercy who administered it and taught in it were committed to high standards from the very beginning, they felt that it should be licensed and that it should be accredited. We had one solid year of affiliation in New York State. Six months of that was at Buffalo General Hospital and six months at the Foundling Hospital in New York City, two months in maternity and four months in pediatrics.

The senior year was exciting. We not only had an opportunity to be in charge under supervision in each of the wards, but we also had what was considered community or home nursing. We had a month of going out under the direction of the physician and caring for patients in their homes. We had another month when we did maternity nursing out in the homes. We would assist the doctor in the delivery, and that was always an exciting experience because most babies were born at night. We would be picked up by the doctor, be taken to the home, assist the doctor during that delivery and care for the mother and the new baby before we returned to the nursing school.

Our classes were taught by the Sisters of Mercy, and they were also supervisors and clinical guides on the hospital wards. They provided a community setting for us in which to watch them, where we would be guided by them and be encouraged by them to love nursing and where we could practice the highest form of nursing that we were able to perform.

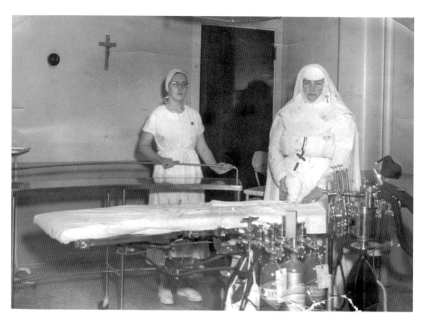

A Madigan operating room. *Courtesy of Houlton Regional Hospital.*

After graduation, Sister Consuela worked as a private duty nurse:

> *I can vividly remember the young boy, how ill he was and how cautious I was in providing care for him. But of course, it was not that much different than being a senior nursing student because I was in the same hospital. The same doctor was there; he was familiar to me. The Sisters, the supervisors, were still around. I had the guidance that I needed, but I was devoting all of my energy and time with this one child. We were responsible for the patient at night. There was a cot, sometimes in the room, sometimes in the corridor outside the room, and if you didn't hear the patient—you usually did—but if you didn't hear the patient, the staff nurse on duty would alert you that the patient needed something. It meant also that you were off from 1:00 p.m. to 5:00 p.m. in the afternoon. The nurses on the staff on that unit were responsible for the patient during that four-hour period, but you were on twenty-four-hour duty as many days as they were there. It could be twenty days, and you got five dollars a day. Two kinds of people had private duty nurses: those that the doctors felt it was necessary to have that kind of intensive care available and the others who could afford to have private duty nurses just to have the extra care that they could receive. You might be called for either kind of a case, and you accepted either.*

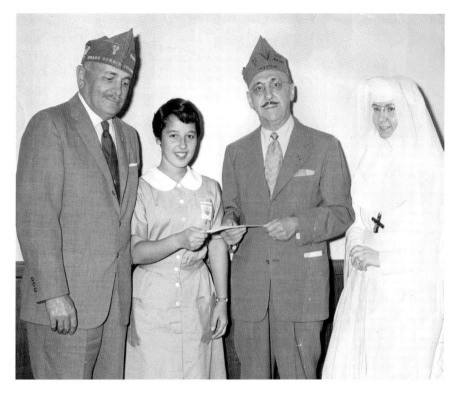

The scholarship award for Ann Marie Gomez, a Mercy student, with Sister Consuela in 1965. *Courtesy of Ann Marie Gomez Cady.*

After working in New York City at Saint Clare's Hospital, Sister Consuela returned to Maine and entered the convent in 1944:

> *In September 1946, I was missioned back to the Madigan Hospital as the director of nursing. There was a school of nursing there at that time. And of course, I had great loyalty to Madigan Hospital. I was very happy to go back. Then, in 1952, I was missioned to the Mercy Hospital in Portland, where I was responsible for a school of nursing and a 212-bed nursing service. I was there until 1974. I came to Saint Joseph's College in 1974 and stayed until 1987. In all those years, I was immersed in, inspired by, involved in nursing.*

Sister Consuela talked about people who had inspired her in her career:

> *Florence Nightingale, of course, comes to mind. I hesitate to name people because then I would be leaving out some people whom I equally esteem.*

But there's a common quality in these people who are mature, courageous, visionary, selfless, industrious, intelligent, compassionate. Those qualities you find in most nurses. Most good nurses have all of those qualities in one degree or another. I usually learn from association with good nurses, wherever they are. We got to know the founders of the Sisters of Mercy as students, and later, we saw in Catherine McCauley a wonderful example of a nurse leader. Although she was an educator, not a nurse by education, she was a nurse by design, I would say. Her care of those in need, especially those who were underprivileged, was always an inspiration to me.

I had the opportunity of watching very competent nurses caring for an acutely ill person. I could see the rapport being established immediately between the patient and various nurses. Later, one of those nurses said to me, "I marvel at sick people, how they reach into themselves somehow or

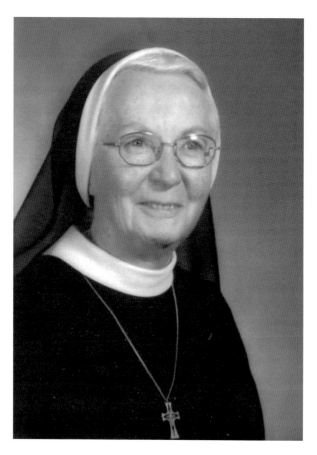

Sister Mary Consuela White. *Courtesy of MSNA.*

other and have the stamina, the resilience, the determination to go through what they go through and not complain and strive to get better." I heard myself saying, "There's a strength for healing within each one of us, but patients need the strength of a good nurse to recognize that and to help them realize it themselves, and therefore, begin to heal."

I think nursing is one person tapping into the strength of another person and helping them in a mutual endeavor to restore health—to cure, if possible, but to care, always. Patients can distinguish between nurses who make a difference and those who are sort of mediocre or don't make a difference. I think what it is, is that connection or that dynamic that occurs, or that chemical reaction that somehow happens because the nurse wants for the patient what the patient wants for himself. There's a bit of a mystery about it. It can't be described. It can't be captured. It can't be written about. It can't be packaged. It can't be understood fully unless you've either been a patient or you are a nurse.

In terms of the future challenges in nursing and healthcare economics, Sister Consuela said:

I would like to say to the students that love is the most healing thing of all. Their greatest, their sharpest tool, their most important tool, is themselves. They will take competence with them if they continue their education. They will gain wisdom if they take time to reflect on what's going on during the day, if they talk to their Creator about their problems and about their joys and if they keep in touch with themselves, their better selves. And if they love themselves, they'll love their neighbor. It's as simple as that.

Life is simple. We complicate it.

WORLD WAR II AND CHANGES IN HEALTHCARE

1940–1959

B y the end of the 1930s, America had become acutely aware of the war in Europe. Hitler's invasion of Poland increased the possibility that this country might become involved. The nursing profession rallied to the call for an adequate supply of nurses. Major nursing organizations, the Red Cross and the nursing units of the federal government met, and the Nursing Council on National Defense was born. This was later known as the National Council for War Service (NCWS). The organization's mission was the recruitment of nurses for a war and of students for schools of nursing.[36] The NCWS depended on state nursing associations to accurately count graduate nurses in the country. In 1941, that number was almost 290,000; of those, 173,000 were actively practicing, and 100,000 would be eligible for military service. The organization had a target of 3,000 nurses per month for potential recruits who were young and single, and the council aimed to raise enrollment to schools of nursing by an impressive 50,000 to 65,000 recruits.[37]

The goal of increasing student nurse enrollment proved to be difficult. War work paid well, and nursing schools had the reputation of offering hard work and low pay. Nursing had an image problem. Recruiting posters that espoused the promising opportunities for entering nursing were an attempt to change that image. The U.S. Cadet Corps Program was created in July 1943. A massive effort involving cinema, radio and magazines promoted the Cadet Corps. More than three hundred national radio programs

broadcasted information about the corps, and film stars posed with pretty cadets in Hollywood. The corporate world contributed by featuring cadet nurses in ads for Eastman Kodak, Pond's Cold Cream, Kotex, Pepsi-Cola, Old Spice, Sanka Coffee and the National Biscuit Company. The Office of War Information distributed several million leaflets and 2.8 million cards to towns and cities across the country. Thousands of department stores, post

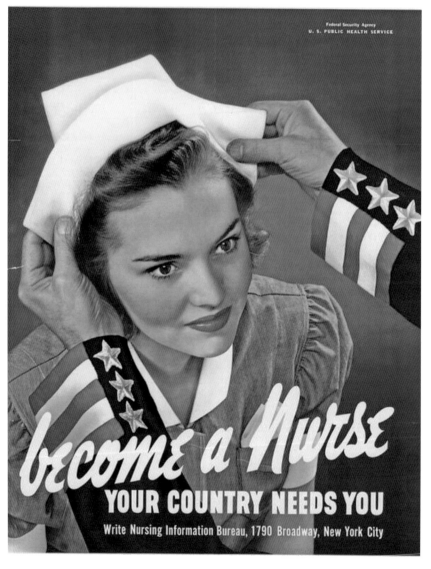

A World War II recruiting poster.

offices, pharmacies, hospitals and schools prominently displayed Cadet Nurse Corps posters. Articles and ads about the Cadet Nurse Corps appeared in the most popular magazines, including *Collier's, Harper's Bazaar, Ladies' Home Journal, Vogue* and hundreds of others. The cadet uniforms were an important element of the recruitment campaign. Leading fashion designers brought fashion models to a special luncheon at the Waldorf Astoria in August 1943 to show the renditions of the cadet nurse uniform. The corps had enlisted the help of several fashion editors to choose the most attractive summer and winter uniforms. The summer uniform consisted of gray- and white-striped cotton, including a jacket suit with red epaulets and large pockets, a simple round neck white blouse and a gored skirt. The winter uniform was a "guard's coat of gray velour belted in the back with pockets and red epaulets, a single-breasted gray suit with button pockets and a white round neck blouse."[38]

In 1944, Vanguard Films produced a ten-minute film, *Reward Unlimited*, which starred Dorothy McGuire as cadet nurse Peggy Adams and co-starred other popular screen artists of the day, including Spring Byington. The documentary was distributed to 1,600 theaters and viewed by an estimated audience of ninety million. Actresses donning cadet nurse uniforms were also featured in other films, such as Shirley Temple's *Kiss and Tell, Lady on a Train* and *The Blonde from Brooklyn.*

In addition to having a glamorous image, the Cadet Nurse Corps program had no fee for tuition and uniforms; it also paid a stipend to the cadets. The corps paid thirty-five to forty-five dollars for room and board during the first nine months of training. The usual three-year program was accelerated to thirty months, with students agreeing to either join the military or work as nurses upon graduation.[39]

———

Eleanor Sargent was born on April 28, 1925, in Millinocket, Maine. She described how she became a cadet nurse:

My parents were Carroll and Florence Sargent of Mount Chase, Maine. My parents moved to Patten in 1946. My dad was a farmer, millworker, town clerk, tax collector and also served on the board of selectmen in both Mount Chase and Patten. My mother was a housewife, maid, cook, telephone operator and, finally, a dental hygienist. She went back to school

when she was sixty to become a certified dental hygienist. She retired when she was seventy. Just a bit of trivia: when Mother died, they closed all the schools in Patten at noontime so the children could go to her funeral. The place was mobbed.

About my childhood, this is a subject that I could go on and on about. I grew up on a farm in Mount Chase during the Depression. We learned to work, share and always look after our neighbors. We didn't have much money, but what we had, we shared with those less fortunate. I think that was the foundation of my existence. I always took care of the sick or hurt animals; perhaps that is how I got involved in nursing. We didn't have electricity, TVs or computers.

We walked a mile to school every day, in rain, snow or hail, even in the sunshine. I looked after my younger brothers and sisters. The schoolhouse was a one-room building with an outhouse and one teacher for nine grades. She is the one you should be interviewing! The older children helped with the younger grades. We always had plays for Christmas, and the whole school participated. There were no hot lunches.

I worked my way through high school. Otherwise, I would have had to walk five miles to school every morning and five miles back. The nursing home in Patten used to be owned by the Howes. Mrs. Howe had broken her hip and needed help with the work. It was three stories high, and the third floor was a ballroom. I scrubbed those beautiful stairs all the way to the top, many times, then would wax and polish them.

After graduating in 1943, I went to work as a domestic for a lovely family in Bangor. I always felt that the Lord looked after me, and He still does. Right next door to them lived a doctor. He was not just any doctor; he was the hospital director of Eastern Maine General Hospital. One day, I happened to be outdoors doing something or other when he came home. He asked me if I would like to be a nurse. I told him I would love to but that we were very poor and couldn't afford it. That is when he told me that the army had started the Cadet Nurse program, and he could get me in it.

Here I am, many years later and still as grateful as ever. After graduation, I went to work at Milliken Memorial Hospital, in Island Falls, Maine. There were no elevators, so we transported patients on a stretcher by hoisting them up on our shoulders. Just before I was forty years old, they started the school of anesthesia at EMMC. I applied, was accepted and graduated with a CRNA degree [certified registered nurse anesthetist]. *This changed my life completely. I have worked all over the USA. I am licensed in eighteen states. I worked as a medical missionary with Feed the*

Children from 1985 to 2003. I have received many awards, one being from Husson College: Outstanding Nurse of the Year. If you look, my picture hangs somewhere. I never went to look at it, as I'm sure it is awful. I received the Mary Ann Hartman Award and an award from University of Maine for outstanding work done with women and children. Again, my picture is there; I am not in dressed-up regalia but in scrubs holding a child in Honduras.

Under the direction of Lucile Petry, the cadet program operated within the U.S. Public Health Service, Division of Nursing Education. The recruitment campaign was an immense success. The program ended in 1948.[40]

In December 1941, there were fewer than one thousand nurses in the Army Nurse Corps. Those nurses who had already graduated from nursing school could join the Army or Navy Nurse Corps.[41]

———

Reitha Hodgkins Scribner graduated from nursing school in Calais in 1925 and served in the Army Nurse Corps from 1940 to 1945 with the rank

Graduation celebration, Calais. *Courtesy of Calais Regional Hospital.*

Above: Graduation day, Calais. *Courtesy of Calais Regional Hospital.*

Left: A World War II Army Nurse Corps recruiting poster.

of J-3 captain. According to a family member, she was in London during the blitzkrieg when the Nazis were bombing the city, and she treated both friendly and enemy wounded. Scribner died in 1990, but to her, "a patient [was] a patient, with no care as to race, religion or country of origin."[42] She was buried in Calais, Maine, with full military honors.

———

Alice Zwicker, from Brownville, Maine, graduated from the Eastern Maine General Hospital School of Nursing in 1937. She worked in the operating room after graduation and became a head nurse. When the call to serve her country came, Zwicker answered, and she joined the Army Nurse Corps. She rose to the rank of second lieutenant, serving in the southwest Pacific Theater–Philippine Islands. Nurses from both the Army Nurse Corps and the Navy Nurse Corps were stationed in the Philippines before a series of Japanese attacks on U.S. outposts in the Pacific, including Pearl Harbor, the Philippines, Guam and Wake Island. The land battle for the Philippines raged for months, and U.S. forces eventually retreated to the southern tip of Bataan and another small island, Corregidor. Eventually, these also fell in the spring of 1942, and eleven navy nurses and sixty-six army nurses and one nurse anesthetist were captured and imprisoned in and around Manila.[43]

Zwicker was imprisoned at Santo Tomas University, along with four thousand civilians. Throughout their imprisonment, the captured nurses continued to care for their fellow prisoners. Typical illnesses included beri-beri, dengue fever and malnutrition. Zwicker lost twenty-five pounds and suffered from beri-beri, a disease caused when there is a deficiency of vitamin B1 (thiamin). Zwicker's family was notified of her capture, and the people of Maine were aware of her fate because it was reported in the state newspapers. Apparently, Zwicker had concerns about her life when she left for the Pacific and, according to her sister, had made arrangements for part of her pay to be sent to her parents. Zwicker let them know that it would be a signal that she was OK if the monthly allotment came. If the allotment did not come, something had happened to her.[44] After three years of hardship, the nurses of Bataan were finally liberated in February 1945.

———

MAINE NURSING

Eleanor Hill spent her military time under many difficult living and cultural conditions that demanded flexibility and perseverance. At age ninety-one, she shared her recollections of that distant time. Hill was born in Brewer in 1917. Although she had admired an aunt who was a nurse, she was not sure what she wanted to do with her life. Her uncle, an orthopedic surgeon, encouraged her to attend Eastern Maine General Hospital School of Nursing:

When I came out of training, they offered me a job at Eastern Maine as an orthopedics supervisor. I was very young, but Dr. Woodcock and Dr. Silsby said, "We'll train her." That's what happened. I was there for three years. Then I decided that I wanted to go in the army. I couldn't seem to hold myself back. I was going to join the Maine 67th General Hospital War Unit. Alice Zwicker and I were good friends. Zwicker went off to the army. She went to Texas. My director of nurses said, "I can't let you go now. You're needed here too much."

I finally was able to go to Camp Edwards in Massachusetts. When I think back about it, it was a terrific experience but something that I'd never want to do again. I was over in Africa, Italy and France, and I was there for three years and never came home. We had some hard living, and we had some good times and bad times.

After about four months at Camp Edwards, those at the camp were shipped to North Africa. There were six hundred nurses that went over in the cargo of six ships. We landed in Oran, at a small station hospital. The first night, we slept on the ground and almost froze to death. I was so cold that I got up and thought I was going to build a fire. I met one of the MPs, and he said, "You're in a blackout, Lieutenant!" We spent five days in Africa going from Oran to Tunis. We had to sleep in shifts. When we first landed, we were given three cans of K-rations a day, three cans of cold beef stew and pork and beans, and they expected us to eat those.

We were on Goat Hill for three or four months, trying to get everybody situated. Finally, we were sent to Tunis in the city of Bizerte. There was a row of tents, each of which represented different medical specialties. We ended up in a psychiatric tent; it wasn't the best arrangement. I didn't care for psychiatric work, but it was a good experience. The tents did not have floors. The commander said, "If you want floors, you'll have to go out and use your womanly wiles to get floors." It was awful. We took silk stockings with us, but we couldn't keep them. There were little silver bugs all over the place, and the bugs ate them. We had at least two air raids every single night. Most of the patients were shell-shocked. We had one unit with

Italian prisoners of war. They were so upset when we had the air raids that they jumped down the latrines.

After Africa, we went into Italy. We were outside of Naples with the 36th General Hospital Unit, which was from Wayne University in Michigan. I was there for nine months. We still were in a small station hospital where two nurses ran the operating room. We were on call every other night. That was the way we worked.

Then they moved us into southern France, and we had to work our way to Dijon. They didn't have transportation because they needed gasoline so much. They put two nurses on each gasoline truck and sent us to Dijon. We took over a cavalry unit. We had the best quarters of all time

Army nurses in France. *Courtesy of the family of Mabel Hill.*

there. We had a little apartment, four of us, a kitchen and two bedrooms.

I was in the operating room all the time. We worked hard. We specialized in thoracic surgery and brain surgery. We had two doctors that were specialists in that, and we had to do a lot of secondary closures. I was working one table, and the doctor was working the other table. We had patients from seven o'clock in the morning until nine o'clock at night, just closing them up, getting them ready to send back to the States. Then we went to Paris for about four months. I was in orthopedics there. Then we were sent to Phillip Morris [a staging camp near Le Havre] to be discharged. We waited for three months for a ship home.

After the war, Hill attended the University of Maine. There was no nursing program there at the time, but she was able to convince the administration to allow her to pioneer her courses. She received a BA in liberal arts and nursing. Hill then married and had two children. She passed on the legacy

of a nursing career to her daughter, Debbie Hill-Hunter, who became a nurse midwife, and to her granddaughter, who at the time of the interview was a nursing student at the University of Maine.

———

Another Maine nurse who served her country was Agnes Flaherty. She was born in Portland, Maine, on November 19, 1919. Her mother was Anna Welch Flaherty, a housewife, and her father, Mark Flaherty, was a Portland police officer:

I went in April 6, 1942, and World War II started in December of 1941, so it was a very patriotic time for many nurses. A very large percent of American nurses joined the military at that time. In any event, it was a patriotic response, and those of us who joined at that time were very pleased to be able to. Before the war, my mother's sister was a nurse. She graduated from the same nursing school that I went to, so I think it was kind of a family tradition. There were army hospitals, but actually I joined the Army Air Corps. I went to Grenier Field in Manchester, New Hampshire. Grenier Field had what was called a station hospital, and it served all of the military that were assigned there. It was an interesting time, and I graduated from a fairly small school. One of the really big incidents in those early years was that we had a plane crash at Grenier Field, and the crew, many of the crew, had very severe burns. That was quite an experience because in 1942, we didn't have the knowledge about burns or much of the treatment that's done today.

When I went overseas, we had what they called temporary housing, and the station hospitals were just like the temporary housing that's built today, but they made them into hospital wards. Now viral pneumonia had not been diagnosed prior to World War II. The medications were not available in 1942. We did a lot of bedside nursing. We recognized when people had high fevers. We used to bathe them to bring their temperature down.

In the Army Nurse Corps, we had a lot of medical corpsmen, young GIs who had some training; they really were kind of comparable to LPNs [licensed practical nurses] *today, but they were trained quickly, and they were invaluable. On flights during the air evacuations, which I did, there was one nurse and one corpsman to care for generally twenty-four patients that we were transporting from the forward areas to the back areas. I was in the*

Pacific Theater, so we went from Tarawa to Hickman Field in Hawaii on Oahu and then from Oahu to the United States. It was related to the invasions because if there were not any wounded to be evacuated from the central Pacific area, we worked in the station hospital at Hickman Field.

This is kind of a funny story: all the men wore shorts, but we always wore the long sun pants. It was very hot on the planes, so this roommate and friend of my mine and I decided we'd cut our sun pants off into shorts. It went out over the total Pacific area that no women will be wearing shorts in this command.

The one thing about the American GI was they always had a great sense of humor. So they would always say, "Oh I knew you in high school. Didn't we used to go together?" I always reminded him or her of someone. I was in the Pacific Theater, and most of our patients were marines, and they had really been fighting in the central and southern Pacific. But they were always so great on the planes. They always had something to laugh about.

I was in the Pacific from April 6, 1942, to September 1945, and during that total time, we had only one patient die on the planes. Now part of that was that they were supposed to be fairly stable, but the other part was that the nurse had the privilege of refusing to take a patient on board because she didn't have the resources to adequately care for him or her. But that still was quite a record, and that one death was because the [patient] had an overwhelming infection. There were a number of psychiatric patients; some of the military, the GIs, the marines, really had psychiatric crises, and in the very beginning, we tried to evacuate them all on the plane, which may have been twenty-four patients at a time. But that happened just twice. It was unmanageable. So after that, there were no more than five psychiatric patients on each patient load, and all the others would be non-psychiatric or would be surgical.

It was a privilege to be there and to serve and to help. The flights in the Pacific in those days were averaging twelve hours in the air; we had no jet planes. These were prop planes, so they were much slower than today's planes. So what happened was that we would go from the Philippines to Guam or Saipan, and we would take all of the patients off the plane and put them in what we called station hospitals or holding areas. We'd get them off the plane and have a physician, a flight surgeon, check them out if the nurse was concerned about anything. But we usually took them off to bathe them, to make it more comfortable for them, and then they would be reloaded and evacuated to Hawaii and then back to the States.

The flight nurses in Europe had much shorter flights. Our flights were very long flights. There was an air unit that was stationed at Fiji; one time, I remember I went into Fiji to pick up patients. So I know on my plane we had two or three nurses that came back with us who needed medical treatment and care. We evacuated the nurses who were prisoners of war in the Philippines, too. We picked them up and brought them home. Admiral Nimitz was the commanding officer of the Pacific Theater. But when the troops went into Tarawa, when the Japanese had the island and the Americans went in to claim the island and to conquer the Japanese, quite a few marines and GIs were lost during that invasion. Then we went in and picked up the wounded as soon as an airfield was secured. We had to wait until there was an airfield. Our planes—we flew in the C-54s, which were four-engine prop planes—were the largest air-evacuation planes at that time. Now, many of the flight nurses that served in India and in Europe were in what they called the old C-47s or C-53s. Those were two-engine prop planes, and I think they held eighteen patients. We held twenty-four. They were screened by the flight nurse or the flight surgeon before they were boarded on the plane, and we had to do just like we do today. We had to have a little history of the patients. We knew what to do and had standing orders for the care that we were giving. We did have plasma on board if it was necessary—in case someone went into shock and we needed to treat them. We had the equipment that was necessary. Some of the patients had casts on. We had to be sure that if there was too much swelling and pain, we had the instruments to relieve the pressure.

All of the different equipment and the medicines weren't available in those days, either. Although, on the island of Canton, we treated a patient at an underground hospital with the first penicillin that was ever used, and he made it. He was very sick. We didn't think he was going to live. We specialed him around the clock. You had to use your knowledge and your experience to care for patients; some of their injuries are ones that you never expected to care for, and you really had to adapt. Many times, the nurses were on their own; there wasn't a flight surgeon on the plane. The head injuries were of particular concern because of the altitude. I made one flight from Hawaii to California, the flight surgeon and I made it, and we had five head injuries on board. We were really scared. We had twenty-five or twenty-six patients, but five of them were head injuries. We weren't sure what was going to happen because of the altitude. We had so many warnings that you couldn't

take patients up in high altitudes. We watched them very carefully. We took their vital signs frequently; they did fine. They got to California, and they were great.

The growth in the knowledge in medicine and in healthcare during World War II was just phenomenal; the advances in treatment of burns, fractures and all kinds of trauma and head injuries were immense. Because of the number of casualties, what was learned was almost unbelievable. Air evacuation was wonderful during World War II because there really was a lot of pioneering done at that time. But we could get patients back to the most advanced facilities in the United States, whether it was in Denver, where Fitzsimmons General Hospital was, or Walter Reed in Washington, D.C. That was the wonderful thing about American healthcare; there was so much concern about doing the best we could possibly do for any of the military who were injured during the war. It was just wonderful.

Agnes E. Flaherty died in 2008 at age eighty-eight in the Maine Veterans' Home in Scarborough. During her more than forty-year career, she was one of the most highly respected nurse leaders in the state of Maine. She served as the assistant director of nursing education at Mercy Hospital from the late 1950s to 1960. For the next ten years, she was the executive director of the Maine State Board of Nursing. She was active in the MSNA and served as president. She then went to Maine Medical Center, where she served as vice-president of nursing for ten years. She obtained a master's degree from Catholic University. After

Agnes Flaherty. *Courtesy of MSNA.*

the war, Flaherty remained with the 1125th Army Reserve in Auburn for more than twenty years. There, she was the chief nurse from 1968 to 1979. She received the Air Medal in 1945, marking the first time flight nurses were decorated in the Pacific Theater.

THE KOREAN WAR ERA

Blanche Alexander was born in Connecticut, one of seven children in a Polish family. She graduated from the Women and Children's Hospital in Boston. After working several years, she joined the U.S. Air Force Nurse Corps on October 3, 1953. Alexander explained, "The fighting in the Korean Conflict ceased in July 1950, but the official negotiations did not end until the end of November 1954. I had wondered why I was considered a Korean War vet, and this explained it for me." Talking about her reasons for joining the service, Alexander noted that her three brothers signed up to serve in World War II before they were drafted. She was a single woman working at a twelve-bed hospital in Damariscotta and had a sense of wanting to see and do something else. After basic training, she was sent to Warren Air Force Base in Cheyenne, Wyoming, where she worked in labor and delivery and served for two years. She recalled that soldiers with rheumatic heart disease were sent to the base hospital to be treated. The disease was related to untreated streptococcus infections, and penicillin had just recently become available to the public. She became eligible for the GI Bill, which helped pay for her bachelor's degree in nursing. Alexander went on to earn a master's degree and taught community health nursing. After retiring, she worked to develop a senior center in her community:

> *I went into nursing school in 1948; all my life, I always wanted to be a nurse. The beauty of it was that I grew up poor. We lived on a farm and didn't have any money to speak of, except we had food and kept a roof over our heads. My sister, who was much older than I, was working and paid for the books and uniforms. It was my way to get an education, and I've always been so grateful for that because, otherwise, it would have meant going to work in the woolen mill. I grew up in Norwich, Connecticut, and that was probably the only job available. You went to work in the woolen mill or you became a secretary, but even that required some sort of*

Blanche Alexander. *Courtesy of Elaine McCarty.*

education. Anyway, it was the start of a wonderful life for me because I got an education and had a very worthwhile career. I went on to get further education and was the first one in my family to ever get a degree.

My first job was on a labor and delivery unit. I got hired at the hospital I graduated from: New England Hospital for Women and Children. I just loved it; every baby's birth was a miracle to me. It was a wonderful, wonderful thing to be in! Then I got the wanderlust. When I was at Boston's Children's doing my affiliation, I met a nurse from England, and we became friends. She said, "I'm going to Texas to work this summer, why don't you come with me?" So that's what I did. I went to Texas—my first time away from home, my first time on a plane. I don't even think we had jets then; it was a propeller. But I went to work in El Paso, Texas, and there, again, I worked in labor and delivery and GYN (gynecology). I remember the shock of getting off the plane and seeing separate bathrooms for colored and white and separate water fountains for colored and white. That came as quite a shock to me because I had never seen that before. That took some getting used to. Then I decided I had the wanderlust again, so I joined the air force.

After leaving the air force, Alexander returned to Damar. She married and became a school nurse when her children were in school. When the family moved to Ohio, Alexander continued in school nursing:

> *Because I've always been active in ANA, I joined the school nurse's group in Ohio; it was in Dayton. I got involved in forming the Ohio Association of School Nurses. I was instrumental in getting that going. Then I wrote to the governor of Ohio, and I said, "How come you have a day for everybody but none for school nurses?" So I actually have a picture, but I can't find it, of me with the governor of Ohio, who was then Governor Gilligan. So he proclaimed a School Nurse Day in Ohio.*
>
> *I got my bachelor's at Fairleigh Dickinson. That was when we lived in New Jersey. This will bring tears to my eyes because it always does, but that was the greatest time of my life because that's when I got my bachelor's degree.*

When Alexander talked about what was important to the future of nursing, she included collaboration and mentorship:

> *I think that collaboration, being kind to each other, taking the young grads under your wings and not criticizing but helping them to learn, is very important. Belong to your organization because it's so important. I have belonged to mine since I was a young graduate. I think what's important in nursing is that you always think of the patient first, that your chief goal is to make that person comfortable, respect them and help them to get well. Just respecting each other is so important.*
>
> *We are number one as far as the most highly respected profession, and we've got to keep it that way. There is a reason that we're number one. It's because people trust us; people know that we will care for them confidentially and take care of them because we have it in our souls to do that. There is a reason we go into nursing. You've already got that in your heart. Ever since I was a little girl, I knew it was what I wanted to do.*

POSTWAR NURSING

The most typical training during the 1940s was still a hospital-affiliated school of nursing that granted a diploma after a three-year apprentice

The class of 1941, Maine General Hospital. *Courtesy of MMC.*

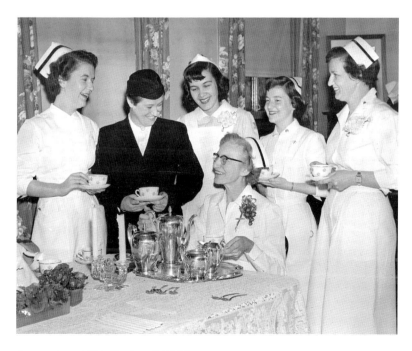

A nurses' tea, 1954. *Courtesy of MMC.*

Around the table. *Courtesy of MMC.*

style of education. The hours were long, the work was arduous and it was a long time before there was hospital laundry service, dietary service and maintenance services to aid the hospital nurses.

————

Mary Catherine Ragan graduated in 1942 from the Queens Hospital School of Nursing, now Mercy Hospital School of Nursing in Portland, Maine. She received a baccalaureate and master's degree from Catholic University. She served as director of the Mercy School of Nursing from 1945 to 1958. She also served on the Maine State Board of Nursing and was a member of the NLN and the ANA:

> *I graduated from Saint Joseph's Academy in 1939, and I called for an appointment at the Queens Hospital School of Nursing. Sister Elizabeth*

was the director. I didn't know the proper way to be interviewed or anything. I announced, "Sister Elizabeth, I'm coming in in September." She said, "Oh, you are?" "Oh, yes," I said. "I planned it; I always wanted to be a nurse, and I only wanted to come to the Queens because that's where I was born." She smiled graciously. She didn't tell me, "That's what you don't do when you're being interviewed."

The patient census was around fifty. It was low. We went to Children's Hospital in Portland for pediatrics for three months, we went to Concord State Hospital in New Hampshire for psychiatry for three months and we went to the Lying-In Hospital in Providence, Rhode Island, for three months. We had a good, rounded education, and we got medical and surgical experience. We had small classes; we had good teachers, and we had no trouble with state boards. Of course, when we were affiliating, the specialty of that institution was what we studied. When we were taking care of the medical patients, we had medical nursing. When we were in the operating room, we had surgical nursing. They had very well-qualified instructors. But I'm prejudiced because I liked it.

The old Queens Hospital was the Diocesan Hospital. The convent was out on Stevens Avenue. The Sisters of Mercy came here in the mid-1850s, I think. So, on State Street, there was a mansion that the bishop had purchased and made what he called the Kings Academy, instead of the Sacred Heart. And then up a block away, he had the Queens Hospital for the Blessed Mother. The Second World War came, and the beds were everywhere. Each building was connected by a runway, but they had to put beds in there. The Hill-Burton funds were available at that time. It wasn't too long after the Depression, so the bishop thought he couldn't have that big expense of building a new hospital. But there was this Sister Annuciata, who was the director of the hospital, and she thought they could swing it. The people of Portland were awful good. They helped with the money, and then they got the Hill-Burton funds, and they built the hospital down at 144 State Street.

———

Mary Elizabeth Lyden also graduated from the Queens Hospital School of Nursing in 1942. During her career, she worked primarily in the area of maternal child health. She worked nights while she and her husband raised

five children. In her nineties, she was still working in a long-term care facility validating treatment plans. She spoke about her career:

I just don't know of anything else I would want to do or would be able to do. I mean I wanted to be with people and take care of them when they needed me. When I was young, yes, I wanted to go and to be a nurse. Even as a child, I took care of my doll and everything else. I've been thinking of it all of my life; I never thought of anything else. My family was living in Eastport at the time because of the Passamaquoddy project. My father was working for that. I went to Portland for I wanted to go to a Catholic nursing school. We had three buildings: Saint John's, Saint Matthew's and Saint Mark's. The surgical one was Saint Matthew's, but the OB [obstetrics] was in Saint John's.

We worked from seven in the morning to ten thirty; we'd have a break from ten thirty to two and then work until seven at night. The nurse that was in charge of the floor usually gave the medications; first, we would observe them, and then we would help. As we got older, the third year, we were probably on our own to give medications, but they didn't have a wagon and go around like they do now with the nurse that's the med nurse. And we didn't have the medications that they have now! Definitely not! There was no penicillin or anything when I started.

We did more than just nursing. We had to keep the rooms clean. We were like the housekeepers, as well. We dusted all the windows. We washed the floors. The kitchenette had little diamond-shaped tiles in the floor, and one of the girls took a glass of water, and she wiped each one of them; she had never done housework in her life! And we all remember that. She didn't know enough to go get a mop or a rag to clean it up! We did work hard. It was just normal. I mean, we expected it.

After graduation, Lyden worked at the Quoddy Hospital. Quoddy was a village where people lived who were working on the Quoddy Project Dam. After that, she worked with a physician:

I would go with him on obstetrical cases around to the homes. We would deliver most of the babies in the homes at that point. The most significant case we had was before the regional hospital was built; the baby was a preemie. I can still remember him. He was so little, and we could just hold him in our hands while we worked on him. I swear he died two or three times, and we just brought him back, and he was breathing! He weighed

A nurse with a boy in a wheelchair, 1948. *Courtesy of CMMC.*

a pound and fourteen ounces.
He was the littlest, tiniest
thing you ever could see!
Another nurse worked with
me; we really worked with
him. We moved him around
and played with him to
make him breathe again! We
had him for a long time, so
he was ours. Then he was
his mother's. And I used to
hear from them until he got
to be about seven years old.
Put the miracle medal on his
incubator. It works!

An Aroostook nurse, 1950s. *Courtesy of Houlton Regional Hospital.*

Susan P. McGrath, a role model to many nurses by emphasizing the importance of membership in ANA, began her training in the 1940s. She later earned an EdD and became a faculty member at Eastern Maine General School of Nursing:

> *I went into nursing school, and I had never been in a hospital before. In fact, I was going to go into education, elementary school education. Then I met somebody I liked, and I thought I'd like to be out of the state of Maine and in Massachusetts. My sister was a nurse in Boston. So I convinced my parents that I could do it. That's how I happened to go into nursing school, and that's how I selected the school of nursing because my sister was a graduate from there. There weren't too many careers open to females, and my sister was very happy in her role. The hospital, the New England Hospital, was one of the more prestigious hospitals in Boston because of its uniqueness with having female interns, residents and physicians. Its nursing school took students twice a year, February and September.*

They always say that they took the three-year programs out because the hospitals used student nurses instead of hiring. Once in a while, there would be, if it was extremely busy or there was an unusually high census in one area, a nurse there on the floor with you. But otherwise, the students were the staff. Of course, you had a lot of nurses in labor and delivery. But on the medical/surgical areas, it was mostly students and the two charge people.

This classmate of mine and I were assigned to obstetrics. It was a big OB department, fifty patients on a floor. We had to give meds, and everybody got milk of magnesia. I suppose it was a half an ounce. After giving meds, we had to clean up the kitchen, wash up all those med glasses—fifty-something med glasses. We decided that we'd use paper cups, she and I, so we measured in a paper cup how much it took of the milk of magnesia to equal a half ounce, or whatever it was, and we did that. I don't know how long we did that; we probably did it a week, maybe longer. Somebody saw, one of the supervisors saw us doing it. She said, "What are you doing?" So we told her. We thought it was a great idea. And it was like the world had come to a stop. First of all, we were threatened with expulsion because we didn't follow the procedure. The second thing was that we had disgraced our instructors. So we had to write a letter of apology to the instructor who taught meds, and the supervisor of OB and to the director, so in case anyone had a problem with this, they had these on file. And then, we were campused. We couldn't leave the environment until this was resolved. Well, we were just sure we were going to have to leave. I was from out of state, and she was from Massachusetts. It was the most traumatic experience.

McGrath worked at the hospital for awhile after graduation. She married and had a son, and then two years later, her husband died. As a young widow with a child to support, she initially went back to work as an administrator. She obtained her baccalaureate degree in Boston because there were no such programs in Maine:

I happened to select Boston College. Afterward, when I came back to Maine, I was on the faculty at Eastern Maine until my son graduated from school. He went to college, and so did I. I went back again and got my master's. I was director of education at Saint Elizabeth's Hospital and Brigham and Women's.

Destiny has a lot to do with everyone's lives. We wrote an article; the director of education at Massachusetts General Hospital (MGH) and I wrote up this consortium that we had, and it was published in Nursing Administration. *The people who were setting up a Project Hope hospital*

in Saudi Arabia read the article, and they thought, "Hey, these people can work together." So they called me from the recruiting office and asked me if I would be interested in setting up a six-hundred-bed hospital in Saudi Arabia. At that time, the Brigham was merging with Boston Lying-In, and I had moved from a three-hundred-bed to a six-hundred-bed hospital. There were a lot of changes. I stayed there until we had the new staff oriented at the Brigham, and then I was looking for a change. They called me again. It was great, and I just went. I decided I'd go, and it was a very good decision. It was a very good decision.

All of the equipment came from Belgium. The directions were all in either German or French, and we had to learn how to use all the equipment. The nurses were from Canada, England and America, and we had Egyptian nurses. We didn't have any Korean nurses at our hospital, but we had all these different cultures working together, and we had some Australians as well.

As educators, we had to set up classes on everything, and orientation was a big deal because the cultural education had to be as important as the clinical. We worked well with the interpreters. I always had a female Saudi interpreter in my classes because I wasn't Saudi. Even though I knew a lot about the culture, there would be questions that I couldn't answer. That was one thing we arranged. I think it pleased them very much because you used them and they knew that you weren't hiding anything and that you were very open to whatever the learning process was.

Later, McGrath worked with Project Hope in China. She felt that she was prepared for dealing with different cultures and societies:

The American nurse is well prepared. Not only was I prepared, but American nurses, especially from all the large hospitals and academic settings where the diversity is already there, know how to handle people from other cultures. The other thing is that in nursing, most nurses have an open mind for new knowledge, and they know they've got to know this in order to function. Nurses learned about the culture. Nurses learned about what's different and how to adapt, and I think that is recognized.

The American nurse is, as far as I know, always taught that she makes the decision for what she does, and if she questions it, there are lines of authority she can approach to take care of it. We make our own decisions. Conceptual learning is very important because we're all so different. Even the physicians are different and how they treat is different. We have to make a decision so that the patient is getting the right treatment.

Donna L. Ault was born on December 1, 1937, at Central Maine General Hospital in Lewiston. She lived in the family farmhouse, which had no electricity or indoor plumbing. Donna attended a one-room school with all eight grades included. It did not have indoor plumbing, but it did have a wood stove. Her high school graduation class in 1956 was made up of fourteen students; thirty students had been in her freshman class. She applied to the New England Deaconess Hospital School of Nursing in Boston her senior year and was accepted:

Dad had prepared me for the worst but was proud and happy when I was accepted, until he drove me to Boston. Nursing students were

Student nurse capes, Saint Mary's School of Nursing, established 1908. *Courtesy of Juliana L'Heureux.*

required to follow strict rules: curfew at 10:15 p.m. except one twelve o'clock a month during the first year. There was 6:25 a.m. chapel on clinical days. Class and clinical attendance was mandatory, barring death. Classes were in eight-week blocks followed by forty hours a week of clinicals. We stood when doctors walked in and opened doors for them; and we spent any spare time in the linen room folding laundry or refolding laundry. Beds were high, wards were the norm. We did respiratory care. A faculty covered the hospital and checked off procedures when necessary. Joslin Diabetic Clinic was at the beginning of diabetic teaching. Food was weighed in grams, blood sugars were tested via twenty-four-hour urine and control was less than optimal. Twelve weeks of OR [operating room] experience taught me that amputations (toes, trans-metatarsal, below the knee) were common. Hodgkin's disease was a death sentence. I saw two young people between twenty and thirty my freshman year die by my senior year. Leukemia in children was fatal. I saw burns from clothing fires and from drinking lye and one iron lung patient. Cardiac surgery was being done on the sickest patients without success.

Ault married in 1958 and graduated in 1959. Her class was the first at Deaconess to be allowed to marry before graduation. She and her

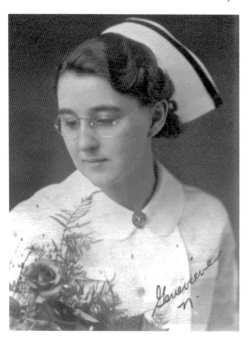

husband moved to Maine, and she worked at Eastern Maine Medical Center. She worked part time after her children were born, and then she received funding to attend a summer program in Texas to get a master's degree. In 1985, she joined the faculty at Husson College, which included, at that time, five faculty members, a receptionist, a copy machine, a coffee pot and only partial partitions. Ault retired in September 2006 at the age of sixty-eight with the honor of receiving the Award for Excellence in Education, Omicron Xi-at-Large Chapter.

A graduate nurse. *Courtesy of Calais Memorial Hospital.*

POLIO AND OTHER INFECTIOUS DISEASES

Edith Beauchamps went to MGH for her nursing education after completing a year of college. Soon after receiving her RN, she received her first baccalaurate with a major in chemistry from Emmanual College. Later in her career, she served as director of nursing at Saint Joseph's Hospital in Bangor. She described her nursing program:

> *That was a thousand-bed, tertiary-level hospital in the middle of Boston. In those days, we worked forty hours a week as a student nurse, and we went to class in addition. It was really mental indigestion and physical exhaustion. It was really difficult. This will strike you as really funny: we had to go to the wards, and we had to take everything off of the beds and clean the springs. We had to take wood sticks and go inside the springs on this spring bed and clean those blessed things and wipe the whole thing down and make the bed. We had to do everything from cooking in the kitchen to housekeeping to patient care, and I just loved it. It was a dynamic place with good teachers. It was very challenging; I mean, it was off-the-scale challenging. Both nurses and doctors taught us. Our classes, like microbiology, were taught by doctors. Surgery would be taught by doctors with nursing care interspersed. At that time, nursing got along really well with physicians. Later in its history, nursing threw the docs out. But at that time, because there were so many docs at MGH, they were often teaching the classes. I loved it there.*
>
> *I did a couple of dumb things. We had a nursing lab, and everything we were going to do with the patient, we had to do in this lab. I had to make a flaxseed poultice to put on my classmate's belly. Flaxseed is red hot when you cook it. It is like cooking oatmeal. You wrap it up in a sheath cloth and then wrap it up in a blanket. Then you are supposed to hold it over the patient's abdomen to gradually acclimate it to the heat. I dropped it right on my classmate's abdomen. She screamed, and I got chewed out for that. The other issue was that I was too quiet. I was told that I either had to find a way to talk to patients or I would be thrown out of school. I found a way to talk to patients. They told me to read newspapers, read magazines, listen to the radio so I could go in with something I could talk about. I overcame that in a hurry. I wanted to stay there.*
>
> *We had a nurse at our elbow all the time that we were taking care of a patient. This woman wore starched white from her calf to her neck; you know how it cuts your neck and it cuts your arms. There she was, watching*

everything we did, every breath we took, every word we said or didn't say. It was really heavy-duty supervision. We were evaluated and given feedback and constantly corrected and redirected. It was a lot of fun, but I got a hell of an education. You know we did because it was a tertiary hospital. We saw everything, major body burns and such, and it was a fascinating place.

After graduation, first, I worked on labor and delivery, and then they asked me to work in the ER. They kept on asking me to change where I was working. I guess they wanted me to be flexible. I went to work on the burn unit, and then they needed a teacher. I was actually teaching at the school of nursing, teaching microbiology when the polio epidemic started.

Boston hospitals had way over five hundred patients overnight. It was just awful. They asked the teachers to come and work on the floors. I was one of the ones who did that. I felt like I was in the middle of a war zone. To help you understand why I say that is that, in six weeks, sixty-four patients had died; that is a lot of people to die. You would usually only see that in a natural disaster or a war or a major accident, like a plane crash. We ended up with thirty-eight people in iron lungs on this big floor.

Initially, with spinal polio, only their arms and legs were affected, but if the organism went up beyond the spine into the brain, it would hit their bulbar center in the medulla, and they would stop breathing. You had to pay close attention to the patient to catch that moment and get them into an iron lung and get it breathing for them. We did not have ventilators then, and CPR [cardio-pulmonary resuscitation] *didn't exist. You had to get them into an iron lung, which would breathe for them, and then you had to give them vasopresser drugs to keep their blood pressure up, and you had to give them IVs. The iron lung is a huge thing. It's at least six feet long, and it is a big iron tin can that can encompass the human body. The patient would be on a stretcher; you would wheel the stretcher into the iron lung, and the patient's head is the only thing that is out. There is a big rubber collar that seals it around their neck. There is a mirror above the iron lung so they can see you, but they can only really see your face. To take care of the patients, whether you were trying to give an enema or whatever you were trying to do, you had to reach through those blessed portholes. Your arms would go in, there would be this rubber seal, and you would have to do everything for the patient through those rubber portholes. You would have one hand here and one hand there, and it was not all that easy. Caring for them was a challenge; taking a blood pressure was a challenge. Taking a pulse was easy; taking a carotid pulse was easy. But you never knew when they would quit breathing on you, and then they would need suctioning. You had to keep*

the airway clear. I would have nightmares listening to suctioning. I never wanted to suction anyone ever again.

Pretty quickly, I got asked to take charge of the night shift, on the eleven-to-seven shift. I said I would do that if they gave me a doctor; all he had to do was be on that level of the building. I didn't care if he slept. I could wake him up fast enough, but I would accept that assignment if I got a physician, so they gave me a physician resident. I was in charge on the night shift. What you have to understand is that Boston nursing had not seen polio; nobody had seen iron lungs; nobody knew how to work with an iron lung; there wasn't any book on this is how you care for polio patients. We learned as we went. The doctors learned, and we learned. It was pretty challenging.

Those of us who were working at least eight or ten hours at MGH would then go do four more hours at a children's hospital to help them because the hospitals were so short of nurses. That was gut-wrenching; I prefer to work with the adults. It's hard enough to have an adult sick, but to have a little kid with polio—you know, zero to four years old in an iron lung. It was really heart-wrenching, but we did that, and I kept doing that because we were just all so needed. The healthcare resources were stretched to the max, and there were tragedies, like a doctor's wife died. He probably brought polio home. One of the docs I was working with got polio. She died. Families would react very uniquely in their own way. There are all of these human stories woven in along with the patient care.

I remember a young man saying as he was coming down the corridor to go into his room, "Don't let me die, don't let me die. I'm working with a psychiatrist. I'm working on my issues. I can't die." Well, he died. You would say you'll do the best you can. We did the best we could, but he died. Another memory that I have that I'll never forget is that I was taking over at the beginning of a shift, and I got a report from a student who had been taking care of a patient. She said, "Well, he finally went to sleep. He's been irritable and anxious, but finally he's asleep." I remembered: you make your own rounds. You had to get your own database. No matter what you hear at report as you take over patients, my recommendation is that you go make rounds and get your own data on how they are. So down I went, and I believe that God speaks to us. So, for whatever reason, I took his blood pressure. He was in shock, that's why he'd gone to sleep. He had gone into shock. We got IV fluids going, and we got him out of shock. He lived. He went home in a wheelchair. We trained his wife to take care of him.

There were two stages of treatment; first was being in an iron lung, and then, if they got over the bulbar stuff where they were able to breathe

somewhat, we would put them in a bed with a turtle, a big huge turtle shell that had a hose that came over the center of it that went to a machine like a vacuum cleaner. This would compress their chest. It would make them exhale, and then the machine would relieve the pressure and the patient would inhale. We got this one patient into that kind of a turtle shell, and we sent him home. He got home, and he got back to work at MIT in his wheelchair. He couldn't walk. It had left his legs paralyzed.

When the polio infection would hit patients' bulbar center, you would have to do a trach [tracheotomy] in a hurry. You would have to get them in an iron lung and do a trach because they couldn't cope with the secretions. You needed to blow up the trach cuff so they wouldn't aspirate their own secretions. When we started to do a trach, we did them right on the floor in the treatment room, which was a room with a stretcher in it.

The staffing was very short. I was responsible for all thirty-eight patients. I had people helping me who didn't know what they were doing, so you were always training. We had student nurses. I would have had a couple of other RNs, maybe three, and maybe a student or two, and I'm

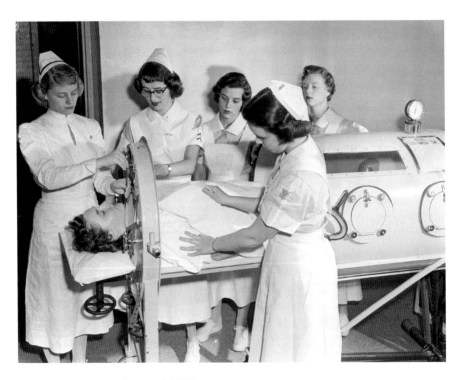

Iron lung instruction. *Courtesy of MMC.*

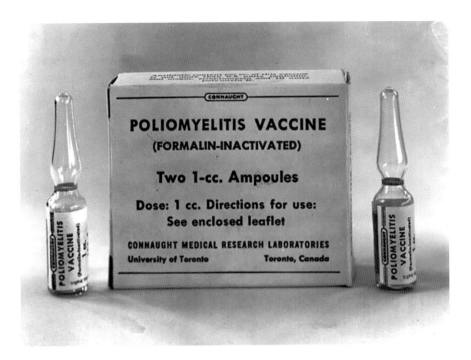

Polio: public health victory!

not sure we had many nursing assistants at that point. We had very thin staffing, so you were running all the time. Nobody worried about patient-to-staff ratio in those days. There was some kind of staffing on the floor, but we had to make do. I was constantly teaching. I had to learn quickly how to care for these people, and then I had to teach and teach and teach. People would step on the cord and inadvertently unplug the iron lung and come running out, saying, "My patient's getting blue!" And you would run in. You learned to look for two things. The two things that would typically happen would be that they unplugged the thing or they left a porthole open. Either of those things stopped the whole breathing function, so the patients would get blue. I learned very quickly to check all the portholes and to plug it in again and then tell them everything was fine and to keep calling.

Nursing changes you forever. You look at people, even people out in a crowd, with your nursing assessment eyeglasses on, and you've seen suffering. You know you've seen really terrific suffering and pain, so you're never again the naïve young person. You're sobered, as doctors are sobered. You realize how precious life is and that you don't want to squander it. You know it really develops a seriousness of purpose and a value of life. I am

*delighted I'm a nurse. I don't want to say it's been a blast because many
people would misinterpret that. It's just been a joy-filled opportunity for me,
a rewarding life.*

In 1952, there were fifty-eight thousand cases of polio in the United
States, the highest ever recorded.[45] An inactivated polio virus vaccine was
developed by Jonas Salk; it was put into use in 1955 in the United States.
Albert Sabin developed a live, viral oral vaccine licensed in 1962.[46]

Elaine McCarty discussed additional communicable diseases prevalent in
the '50s. McCarty was a nurse during the Vietnam War and spent many
years in the reserves. She became a nurse practitioner and provided services
to a Maine island community; she was also a community health nurse and a
nurse educator. McCarty graduated from a three-year school of nursing in
1956 and worked as a nurse for forty-five years. She retired from the Army
Reserves as a full-bird colonel:

*When I began, nursing was much more patient directed. You were assigned
so many patients. There were patients with whatever illness they may have,
and you had to keep them comfortable, pain free, reassured. It wasn't the
technical, machine-oriented nursing that it became later on. Because I was a
nurse for so many years, the transition to various and sundry machines that
we used on people was gradual. So it was much more rounded, and nurse's
aides only had a minimal role. You were still responsible for pulling patients
up in bed, moving them around, keeping them comfortable and getting them
out of bed. And in between, you gave the medicines.*

*I worked in the communicable disease unit of the hospital where I
graduated. I worked nights. I did that for about a year, and then I left
and went to Florida and worked in a very small hospital. I was there a
few years. My job list goes on and on. There was polio, but there also was
tuberculosis, meningitis, some pertussis [whooping cough]. The polio
epidemic happened while I was still in nursing school. There were some
post-polio, large communicable disease units. By large, I mean probably
sixteen babies with whooping cough. Babies died with whooping cough.
There was always a unit for infections; I stayed all the time because these
babies were very ill.*

THE DEVELOPMENT OF POSTWAR COLLEGIATE EDUCATION

In 1947, at the fifty-third convention of the NLNE in Cleveland, Ohio, President Agnes Gelinas spoke of pressures being put on nurse educators from two separate issues: the needs of patients, as well as the shortage of nurses.

Many years ago, hospitals favored the establishment of their own schools of nursing because the nursing service supplied by students was economically advantageous to the hospital. As time passed, they found the progressive school to be expensive. The colleges and universities, which had schools of nursing as a part of their academic circle, likewise had found nursing education costly. In the beginning, they believed that only a preclinical faculty would be necessary; they had learned that to safeguard nursing education, they must appoint larger faculties which will provide instruction in clinical nursing services. The owners of nursing schools were asking nurse educators to determine who should pay for nursing education. The issue was complex; but until our schools have adequate funds, shortages of teachers and students will persist. [47]

Millicent Higgins was born in Houlton, Maine, and graduated from the Liberal Arts and Nursing Program at the University of Maine. This program existed from 1939 to 1954. Higgins received her MSN and her doctorate of education from Boston University. She worked as a staff nurse in Maine and became a nurse educator, helping nurses achieve their BSN and MSN degrees. She recalled:

I decided to become a nurse when I was in my early teens. I'm not really sure why. I wanted to be in one of the helping professions, and I think that's what influenced me as much as anything. My high school babysitter during the war was off to the cadet program, and that may have influenced me as well.

I went to the University of Maine five-year program, and I began in the fall of 1947. We graduated from the university in the fall of 1952, although we had finished our nursing courses the previous year. We affiliated at various hospitals. We went to what is now Eastern Maine Medical

Center (EMMC) for part of our education, and then we spent six months in Boston with labor and delivery at Boston Lying-In and pediatrics at what is now the Boston Children's Medical Center. We also spent three months at a state hospital for psychiatric nursing.

I'd been told there was one baccalaureate program at Colby College, but it had the same problems which eventually caused the University of Maine program to close in terms of finding faculty, finding clinical placements and sustaining quality education. At that time, we went for two years to the University of Maine, where we had a very heavy load of sciences, all of our preparation in that field and some social sciences as well. We also had a few credits in liberal arts. We also spent the summers of our college career in the probie period. For two years, we were pretty much in education, then two in nursing school and one more back at the university.

When she was asked to recall a meaningful incident in her career, Dr. Higgins replied:

This would seem very small to some people, but at the time, it struck me as being a significant thing in relation to our professional role. This was before hospice had advanced very far. There was a hospice in our hospital, but you had to sign up for it. Hospice care wasn't as defined as it is now. We had had a young man on the unit for several weeks. He was dying of lung cancer. He had been seen by an array of practitioners, from IV nurses to people doing the cleaning in his room and all other types of services in the hospital: physiotherapists, occupational therapists. Many, many people knew him and knew about him. He also had family in the area, but I don't know if they realized how ill he was. My students had been taking care of him for a few days. I came into work one morning, and there was a young nurse there who normally worked a 3:00-to-11:00 shift. I said, "Oh! You changed your shifts today." And she said, "Well, George was having kind of a rough time last night, feeling kind of lonely." She continued, "I sat with him until he died." We had come on again in the afternoon, so she'd been there almost twenty-four hours. Nobody else in the hospital who'd been working with him saw the need for that. This is not earth shaking in terms of nursing as a whole, but it really pointed out to me that nurses sometimes see things that other people don't. And as I say, not one other person realized that he was going to die alone, but she did, and she took care of it.

Higgins worked in medical surgical nursing, community health and rehabilitation nursing. She taught at Newton Wellesley Hospital School of Nursing, Boston College and SJC of Maine, retiring initially in 1994. Throughout these years, she was active in Sigma Theta Tau and the ANA in both the Massachusetts and Maine state organizations. She believed that higher education was imperative for nurses. She returned to teach the nursing theory course in the online master's program at SJC, finally retiring in 2011.

According to Higgins, findings in her 1994 research supported the fact that university administrators of nursing programs failed to take into account the importance of working with all groups within the healthcare field involved in education. In particular, the national group of nurse educators was waging a war against the lack of control nurses had in administering and leading nursing programs. Accreditation was used effectively by the nursing profession to gain control of how educational programs were organized and staffed.[48]

The nursing shortage during the 1950s created a different way to educate nurses in a faster period of time. Mildred Montag served as founder and director of Adelphi College School of Nursing in New York until 1948, when she left to pursue a doctorate degree at Columbia University's Teachers College. Her dissertation, "The Education of Nursing Technicians," published in 1951, described a shorter, two-year nursing education program meant to address the nursing shortage.[49] In 1958, with funding from the W.K. Kellogg Foundation, Montag tested the program at seven pilot sites in four states. The program was a success because it attracted a wide range of students, including men, married people and minorities, all of whom were able to afford the two-year option.

According to Marilyn Klainberg, associate professor of nursing at Adelphi, Montag never meant the two-year program to replace the baccalaureate program. Since most schools of nursing were three-year hospital-affiliated diploma programs, Montag's goal was to both decrease the time of educational training and to place the programs in junior colleges. Montag proposed a technical worker in nursing, who was more limited in scope than a professional nurse but whose responsibilities had a broader scope than those of a practical nurse. Montag's proposal also took into account the development of community colleges and the need for nursing education

to be within a collegiate educational framework. Technical education in nursing, according to Montag, must include the curriculum courses in general education, courses dealing with the specialized content in nursing and courses that relate to and support specialized content in the biological, physical and behavioral sciences.[50]

In her 1952 address, Agnes Gelinas addressed another concern of nursing education:

> *First, as nurses, we must believe that sound basic* collegiate education *is the quickest and most economical way to provide nurses with the essential training needed to carry out the technical and professional functions of nursing. Once we truly believe in collegiate education for nursing, then, secondly, we must promote public support of it. We must break away as soon as it is reasonably safe from the traditional apprentice system of education and provide a new education for nurses.*[51]

Muriel Poulin graduated in 1946 from MGH School of Nursing and was coordinator for staff development there early in her career. She is an internationally known administrator and educator whose early work in developing guidelines for the establishment of magnet designation for hospitals was inspirational to Maine nurses, as well as to other professional nurses nationally and internationally. She is a Fulbright Scholar and a member of the American Academy of Nursing. She served on the board of directors of the Southern Maine Visiting Nurse Association, was a member of an early study group for the Hospice of Southern Maine and has been a long-term supporter of the ANA in Maine:

> *Nursing has been the prime focus of my life. I left home to go to nursing school, and I worked all my life both as a staff nurse right up through when I got to be a supervisor at what was really then a city hospital in the District of Columbia. While I was there, I went back to school for my BS degree and got to be a head nurse and then a clinical director. I started out as head nurse on an orthopedic and medical-surgical floor, and then, when I was promoted to supervisor—today it would be a director position—I had all of the medical-surgical unit, the emergency room and what we used to call the central supply, so I had a lot of experience.*

From there I went to Damascus, Syria. I had a bachelor of science degree, and they were looking for someone with a BS degree. In 1953, 1954, those weren't common. I was offered this job. When I was first asked, my reaction was, "Damascus, where is that?" But three months later, I landed in Damascus, Syria. I spent one year there.

As the director of nursing, I was charged with setting up the hospital, Damascus General Hospital, which was in the process of being built. I was a member of a team that went over to help them open that hospital, but because of the political situation, we came home at the end of the year.

I think some elements of nursing are still with us. The basic element of caring for people and trying to keep them whole, I think, is still there. The human element is still there. In terms of knowledge, the nurse today has to know so much because there is so much new material, new drugs, new treatments. But if at all possible, a young man or woman should go through the four-year nursing program.

I can remember the first heart valve patient I took care of. You stood by the bed and could hear the clicking of the metal ball. That's not known today; people wouldn't know what you are talking about. But I can remember standing near a patient who had a valve replacement, and it was metal. And the ball clicked every time there was a pulse; you heard the ball click. If it bothered you a bit as a nurse, you had to get used to it. But just imagine what it felt like for the patient.

When I came back from Syria, I came back to MGH to be in charge of the education department, and almost right away we had this polio epidemic. It was the last big polio epidemic of the world. Most of them [patients] were in iron lungs. We had to recruit, and I think we had to recruit medical students in force. I remember taking a whole class of medical students and teaching them how to run an iron lung. It was something because those things were big, no doubt about it. The goal was, if the power went off, we had enough people to handle the iron lungs by hand. It was definitely a pressure thing, and you had to push the bellows at the end of the iron lungs in and out. That was what would keep the patient going. The iron lung would help the patient survive, and it would relax the patient's body enough that eventually the lungs would start improving a little bit. A lot of the patients were not in the iron lungs; that's where the Kenny packs were used. You would use it every few hours.

I don't remember that we did get sick from patients. I mean if the staff did, it was probably while they were dealing with the public. But I don't remember one case of someone becoming ill the whole time I was working

on that unit. I think people were very frightened, but they were careful, too. You went around with masks on and used precaution measures. I don't think people understood what caused polio and how it was transmitted. We all used the whole bit: gowns and gloves and masks.

In 1972, I went to Boston University as chair of the graduate program in nursing administration. I firmly believe nursing administrators must be leaders for ensuring delivery of comprehensive patient care. And today, you're a vice-president for nursing, and it means that you're dealing with administrators, physicians and assistants that are well educated. They're no longer directors of nursing but are VPs for nursing and VPs for patient care, and I am all for that. You're on the top of the ladder, and you have to function that way.

I am a strong believer in bachelor of science entry into nursing practice. I do think the emphasis on developing nursing education has slowed down because of what is going on with healthcare, what is going on with hospitals, how they are restructuring and how they are merging. We are going to end up with big conglomerates, big corporations. I am afraid that nurses are going to have to fight to keep that patient in focus because...because right now, the focus is on money. I don't care what anybody says, these mergers going on around us are not for the welfare of the patient. They tell me it's for the welfare of the patient. Show me. The patient has to be the focus of our attention. The money is important, but it falls to nursing for patients to remain the focus of care.

Technological advances in healthcare during the decade of the 1950s included the use of blood transfusions, the general use of antibiotics, recognition of trauma care and rehabilitation as new specialties and new uses for nuclear energy. Postwar prosperity and federal funding had begun to build healthcare into the behemoth it is today. Health insurance expansion meant increased hospitalizations, and questions regarding the preparation for nurses would not disappear. Nurses' aides, licensed practical nurses and two-year associate degree nurses joined the hospital-affiliated diploma graduates and college and university graduates who had attained baccalaureate and advanced degrees in meeting the rising demand for nurses.

GROWTH OF HEALTHCARE, TECHNOLOGY AND PROFESSIONAL AUTONOMY

1960–1979

D uring the 1960s and '70s, the civil rights movement, the Vietnam War, the advent of Medicare and Medicaid, the Nurse Training Act, technological advances and social change would profoundly affect nursing and the delivery of healthcare. President Kennedy inspired idealism in Americans to make a better world in both the public and private sectors. His words were also prophetic: "We stand today on the edge of a new frontier—the frontier of the 1960s, a frontier of unknown opportunity and perils—a frontier of unfilled hopes and threats."[52]

After President Kennedy's assassination in 1963, President Lyndon Johnson developed the programs of the Great Society and the War on Poverty. Financial aid to the poor to fund neighborhood health centers and well baby care emerged with the passage of the Economic Opportunity Act of 1964. Medicare and Medicaid were signed into law in 1965; Medicare provided health insurance to those over sixty-five, and Medicaid provided health insurance to the poor. The increased availability of health insurance improved access to healthcare for millions of Americans.

CIVIL RIGHTS

Civil rights became a critical issue in the 1960s as Jim Crow laws segregated much of the American South. Nurses educated in Maine who sought work

in southern states were often unprepared for segregation's effect on nursing practice and patient care. Nancy Ann Blodgett graduated from Mercy Hospital School of Nursing in 1959 and worked in many key leadership roles at Mercy. But immediately after graduation, she moved to Florida and took her licensing exams. She had the following experiences:

> *This was 1960, and I remember that was during segregation, and the hospital that I worked in had a colored ward. They called it that because they weren't black then, they weren't brown, they were colored, or darkies. The colored people went to the basement, no matter what. Your basement level had all of your colored people in it. Your white people, white mothers, went up to a very state-of-the-art maternity unit. Your black mothers went on a back elevator to the maternity unit, delivered their babies, went back down on that back elevator to the colored ward, where there would be three mothers and three babies in a four-bed room. Anybody could come in and visit them. Now, in the white ward, the only ones that could visit the white mother would be the father of the baby and the maternal grandmother. That's the only visitors they could have because of the germs. But if you were black, you were down in the cellar, and anybody could come in and see you. I worked the colored ward a lot because I would work the colored ward. And that was the trouble; most people wouldn't work down there.*

When Blodgett went to take her licensing examination, one of the women she went with was a black woman:

> *There were four of us taking state boards from our hospital. We left in the morning, fairly early. We knew we had to pack a lunch because we couldn't eat anywhere. We couldn't go in a white restaurant with her, and we couldn't go in a black restaurant with her. We didn't even get out of town when this happened. There were high school kids standing on the corner. The black girl was sitting in the front passenger seat, and Sally and I were in the back. They started screaming at us, "Put the n----- in the back! Put the n----- in the back!" It could have been a monkey, a dog or anything, and they wouldn't have hollered at us, but it was a black woman. I was mortified. Then the black woman said, "I'm used to that. Don't worry about that. Don't let that bother you."*
>
> *We got to the first filling station. We had to get gas. Then you didn't pump your own. This man was there, and he took one look at her and he said, "N----- out back." She couldn't use the bathroom; she had to use the*

outhouse. I went in with my dollar bill. I was going to buy four bottles of Orange Crush to go with our lunch. It was one of those old coolers that were dripping wet all the time. I can remember I got out the four bottles of Orange Crush and set them on the counter and put the dollar down. He said, "Are you with that n-----?" And I said, "Well, there's a colored girl riding with us." And he said, "We don't do business with people like you." They would not take my money. We just went to another store. I went in and bought the soda, and then we went out behind a building and ate our lunch.

TECHNOLOGICAL CHANGES

Unprecedented growth occurred in healthcare through technological advances and public policy. The pharmaceutical industry was rapidly developing new and effective drugs. Beta adrenergic blockers, loop diuretics and levo-dopamine to treat Parkinson's disease were some of the drugs

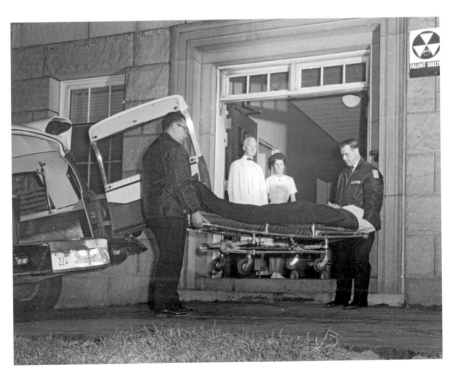

The entrance to an emergency room, 1962. *Courtesy of CMMC.*

Left: A special care unit, 1990. *Courtesy of CMMC.*

Below: A disaster drill, 1970. *Courtesy of CMMC.*

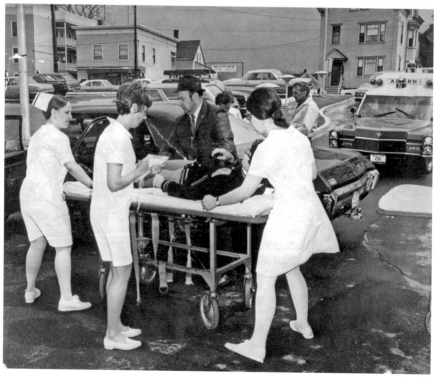

that were introduced in the 1960s. Cardiac surgical procedures such as coronary artery bypass grafting (CABG) were evolving. The artificial kidney (hemodialysis) was developed. Critical care units were opening and represented a totally new concept. Critically ill patients needed close observation, constant supervision and quick action in a crisis where care given by highly trained nurses would rely on the latest equipment and monitoring devices.[53]

———

Margaret Ross graduated from the Mercy Hospital School of Nursing in Portland in 1958. After working at Mercy for a couple of years, she was looking for a change:

> *I went away to California. At the time, job searching meant looking in the classified ads in the* American Journal of Nursing. *Because they were the farthest places away from home I could find, I communicated with some hospitals, and I had a letter offering me a job in Juneau, Alaska, and another one in Long Beach, California. I thought, maybe I've had enough of the snow stuff; I accepted the job in Long Beach by mail before they ever laid eyes on me. I took off with a one-way ticket. It was the first time I had ever been on an airplane, and my foot locker with all my worldly possessions and I went out there and I had a wonderful career.*
>
> *I had many opportunities in nursing that I never would have seen here. I worked in a medical center there for fifteen years and went from a staff nurse to critical care because they were just opening up a new critical care unit. I said, "What's critical care?" "We'll teach you what you need to know," they said. So the next thing I knew, I was a three-to-eleven charge nurse in a twenty-bed critical care unit, and it was wonderful!*

———

In the mid-'60s, courses in Advanced Cardiovascular Life Support (ACLS) were developed. Nurses working in coronary care units learned to interpret cardiac rhythms and to recognize early heart changes that might develop into serious problems and then seek medical intervention. When patients had cardiac arrests, nurses were trained to perform closed-chest cardiac

massage, mouth-to-mouth resuscitation and defibrillation. In addition, they also gave emergency drugs and learned to intubate patients, all of which aided patients with arrhythmias and improved patient outcomes.

Sandra Record graduated from Maine Medical Center School of nursing in 1963. She shared her early experiences of cardiac monitoring and how it impressed her:

> When I graduated in 1963, I went to work in Boston to work at Beth Israel Hospital, and I worked on a medical unit. It was really interesting because it was one great big room, and there were twenty people with just curtains around them, all open. In the side room was Dr. Zoll, who was a physician who had invented the heart monitor, and he was experimenting with it. Part of the nurse's responsibility when you worked was that you had to listen to the monitor, and if the leads were off or if something changed on the EKG [electrocardio gram] and the alarms went off, you had to run...I can picture that to this day, that room where heart monitoring of people was taking place.

Ann Sossong graduated in 1963 from Eastern Maine General Hospital School of Nursing and later went on to receive her doctorate from Catholic University. In the early '60s, she worked in a New Jersey hospital's ICU/CCU (intensive care unit/cardiac care unit). She took an ACLS course when the concept was new. Sossong said, "We learned to defibrillate by going to a pharmaceutical company and defibrillating dogs. We all cried because we were so afraid that we were killing the dogs, but they survived."

Technology influenced all aspects of healthcare and nursing practice. Dottie Barron graduated from Eastern Maine Medical Center School of Nursing in 1971 and developed her career there. She experienced many of these changes:

> The equipment was so different. Everything is disposable now. I went to nursing school and worked the first number of years of my career in a non-disposable world. Every day, when the assignment sheet went out, somebody was assigned afternoon autoclave [steam sterilizer] duty. We had our own autoclaves to do our small trays and things. Everything was reused. With medications, everything is unit dosed and provided through pharmacies now. Then, medications came up in big bottles. When you

think about it, the safety features are much better now. We just had big
bottles sitting in open cupboards for each patient.

Barron noted that, often, technology prolonged life and raised ethical questions that never had to be addressed before:

Now that we have all this technology, sometimes it becomes an issue of ethics:
Have we saved them? Should we save them? What's the quality of life, if
any, if we save them? And those issues didn't really exist when I first started
working because we just didn't have all the technology to save the lives. That's
really hard to deal with. The times have changed; everything has changed.

NURSING EDUCATION

The ANA developed *A Position Paper on Education Preparation for Nurse Practitioners and Assistants to Nurses* in 1965, which stated that the bachelor degree should be the degree of entry into practice for the professional nurse and that the associate degree should be the degree of entry for the technical nurse.[54] Margaret Hourigan began her career in a diploma program and continued her education to achieve a doctoral degree. During her multifaceted career, Hourigan taught in the RN-BSN Distance Education Program at Saint Joseph's College and served as chair of the Nursing Department. Her story reflected some of the frustrations in moving from an RN to a BSN degree:

My father was a physician. I was born when my parents were in their very late
thirties, so I was a younger person with older parents. My father, I can assure you,
did not want me to be a nurse. He said, "You can become a nurse, but you have
to go to a baccalaureate program." Well, I did go to a baccalaureate program
for the first year. But he died at the end of my freshman year, and circumstances
changed. I went home, went to college, another college for a year and then I went
to the three-year program. So by now, when I am getting out without a bachelor's
degree, I am now five years out from my goal of being done by three.

Hourigan continued to explain her experiences in her nursing program:

I went to a diploma program in 1964 because that was what was pretty
much available. But you see, my underlying motive was that I was going to

be much too old if I went to a four-year program. When I started, I went to a really good program, Peter Bent Brigham Hospital School of Nursing. At that hospital, there were no nursing notes. We just recorded vital signs; I didn't know any better. In school, there was a separate doctor's dining room that we were not allowed in, and if a physician came on the floor, we had to stand up. Nurses were looked at as handmaidens—at least, in that setting. I will never forget one of the famous heart surgeons. As a brand-new graduate, when I was working on one of the surgical wings, this cardiac surgeon was making rounds with his entourage. I thought, "Oh, I am going to go listen to this." I was on the evening shift, so I just went up there. I can remember him looking over at me. He was very tall, and I was very short, and he looked down over his glasses and said, "Is there something you want?" And I said, "Yes, I want to listen." And he said, "You are not needed here." I was summarily dismissed! I didn't say anything because I was twenty-two and certainly didn't want to get into a ruckus in front of a whole lot of people. But that helped to frame for me what I wanted to do, and I really started to think about the value of nursing.

I can remember entering this three-year program, and one of the very first things that was said was: "Well, you know, you're going to have to go on and get a bachelor's degree." And I thought, "Oh, for Pete's sake, who made this rule?" And I had no appreciation at that time for what really was the difference. I graduated in 1967. When I went back, I finished my bachelor's degree in 1971 or somewhere around there, and I had to do it because if I hadn't done it then, I would have had to retake all of the sciences because the credit wouldn't be transferable if it was not finished within five years. When I went back to University of New Hampshire (UNH), where I had gone for one year, they were going to make me retake every nursing course. As it turned out, I did take community health, which was wonderful because I'd never had community health. But I had to retake mental health because they didn't know what else to do with me. It took me five years to get back to school, and in the interim, I had been working at the Dartmouth Hitchcock in the SCU and the ICU. It was where they were doing open hearts and all that good stuff. So I had five years under my belt, and I certainly wasn't an expert nurse, but I was good.

As it turned out, during my last year at the Hitchcock, I was asked to teach in their diploma program as an instructor. Now, what did I know about teaching? Not much. But I did know ICU, and that was what I was teaching. There was this nurse educator, Dr. Catherine Shank, who was from UNH and who had students on this unit. She was my first idol in

nursing. We were chatting one day, and she didn't really know much about ICU, and I knew even less about teaching. I said to her, "You know, could I just pick your brain? Can I talk to you about nursing?" I said, "I would be glad to help your students along in intensive care." We had a wonderful trade in terms of helping each other out. When I told her I was applying to UNH, I said to her, "Well, they're letting me in, but they are going to make me redo all of medicine-surgery." I said, "Do you think I really need to do that?" She just shook her head. She didn't say anything negative, but the next thing I know, I didn't have to do it. I thought: there's an advocate. It certainly framed how I have approached continuing education over my career in that we shouldn't make people repeat things if they have already demonstrated the competence. We shouldn't say just because you haven't had my medical-surgery course, you haven't had it. Or just because you haven't had my health assessment course, you haven't had it.

During the 1970s, diploma schools started to close, and more nursing education moved into academic institutions.[55] Because of MSNA's initiatives, Maine was selected as one of nine states to participate in a study advanced by the National Commission for the Study of Nursing and Nursing Education. This study, from November 1971 to December 1972, titled *Statewide Planning for Nursing Education in Maine, 1970–1985*, provided the momentum needed to move nursing education into institutions of higher learning and to give MSNA members the data necessary to strengthen nursing practice and nursing education in Maine.[56]

As the work of nursing theorists expanded, the identity of nursing as a unique body was established and clarified. The purpose of graduate education in nursing was seen as the advance of nursing theory with the goal of improving patient care.

State boards of nursing had long utilized ANA standards of practice in the rules and regulations of nurses. These standards had been guides for practicing nursing, therefore securing the safety and quality of patient care. Nurse practice acts started to describe nursing practice with an independent nursing role in diagnosing and treating nursing problems. Nursing theory, standards of care and nurse practice acts all contributed to the development of the expanding role of nursing.

In her role as executive director of the Maine State Board of Nursing (MSBON) from 1978 to 1997, Jean Caron was a leader in clarifying nursing roles from the perspective of securing public safety and nursing standards of care. She received her diploma in nursing from the Mercy Hospital School

Public health/school nurses, 1969. *Courtesy of Maine State Archives.*

of Nursing in Portland, Maine, in 1953. Her baccalaureate degree with a major in nursing was from Boston College in 1962, and in 1973, she received a master of science degree in nursing from Boston University.

In explaining her role, Caron described how fortunate she was to have Marion Klappmeier as her mentor for the two years preceding Klappmeier's retirement as the board's executive director. "Marion made certain I understood and appreciated that the board was created by the Maine legislature for the sole purpose of protecting the people of Maine from incompetent and unsafe practitioners of nursing," she said. Additionally, Klappmeier encouraged Caron to move toward developing the leadership skills needed to work effectively with the Board of Nursing.

"I realized early on that a significant number of the nurse population in Maine were not fully cognizant of the distinction in roles between the board as an advocate for the public and the professional nurses' association, which advocates for nurses and nursing practice," she said. Therefore, in an effort to mitigate this problem, it became important to engage with the nursing

Jean Caron (left) and Ann Sossong (right). *Courtesy of Juliana L'Heureux.*

community at meetings and conferences. She attended meetings of the nurse executives and other nursing groups, accepted requests from nursing programs to speak to faculty and students and published a newsletter to be disseminated to all currently licensed Maine nurses.

During Jean Caron's leadership at the Maine State Board of Nursing, the discussion began about requiring a minimum of a master's degree to teach professional nursing:

> *The board began this discussion in the early 1980s. At that time, it was noted that a significant number of faculty teaching in Maine's various nursing educational programs held diploma, associate or baccalaureate degrees. Subsequently, following intensive deliberations, the board concluded that all registered professional nurses teaching in Maine's nursing educational programs (diploma, associate and undergraduate) should hold a master's degree in nursing or be enrolled in such. This was a momentous decision and fraught with risks because of the lack of graduate nursing programs in Maine.*
>
> *Although the board had the authority to promulgate its decision, it seemed desirable to make every attempt to elicit a spirit of mutual collaboration*

A nurses' station, 1979. *Courtesy of CMMC.*

between the board and the nursing programs. To that end, the board hosted a special meeting with the directors of the nursing programs to provide them with the opportunity to express their views. Following a lengthy discussion, the board requested a show of hands in support of the board's decision to require the graduate degree. It was a credit to the directors that ninety-one percent of the attendees present supported the board's action.

VIETNAM

Hundreds of military nurses provided care in trauma centers located close to the dangerous combat zones and in the jungles of Vietnam during the war years. Many others served in military hospitals in the United States. Jeanne Krause joined the army while in college. She served at Walter Reed Hospital after graduation. She married, had a family and finally brought the wealth of her experience to her nursing practice in Maine. Krause began her nursing education in a baccalaureate nursing program in Baltimore. Clinical courses were in the junior and senior year:

The school uniform was really taken from Florence Nightingale, as was our graduate cap. Our school was started in 1889 by one of her students. We had a uniform that was a dress, and it had a white pinafore with it. It had blue stripes, vertical stripes. We did have short sleeves, whereas the original uniform had long sleeves. Our dress was allowed to come to the middle of our knee, not above, and you never, ever, ever wore slacks, even going over to the hospital later on in the evening. You always had to be dressed appropriately to go on to the hospital floor to look at charts.

My last two years, I was actually in the military, and I was stationed at the University of Maryland in Baltimore. I was a private first class for those two years. But six months before we graduated, I was commissioned as an officer because, back in those days, you could not graduate and be a nurse and not be a commissioned officer.

After we graduated and passed our boards, I was at Fort Sam Houston in San Antonio, Texas, for my basic training, where we learned to set up a MASH [Mobile Army Surgical Hospital] *unit. In two hours, you had to go from nothing set up to being able to take patients in, even if you weren't totally set up. You had to be able to do that and learn how to debride entrance and exit wounds, and we learned how to do emergency tracheotomies. It was very intensive and really scary because it was during the Vietnam War.*

Then I was stationed at Walter Reed. I worked three to eleven. I had two floors, fifty patients on each floor at the same time. I had one corpsman on each floor. My home base floor [neurology] *had the gunshot wounds to the head. These people were hit in Vietnam, stabilized for twenty-four hours, had surgery in Tokyo and then, four days after being hit, woke up on my floor. We had those plus GI bleeders, which were a lot of dysenteries and stuff that had come over from Vietnam.*

Downstairs was plastic surgery to the face. Walter Reed did all of the plastic surgery to the face that was done by any of the services, whether it was navy or whatever. We had people whose faces were being totally rebuilt. On the same floor was, and I had no idea why, we did face and butt—the people who had gotten hit in the butt and the people who had sciatic nerve damage. We took care of all of them on the same floor.

I was absolutely petrified as a brand-new nurse. I had a lieutenant colonel as a head nurse. I thought she was quite old; she was probably in her forties. I had a six-week orientation on the floor to learn how to take care of these people before I became the three-to-eleven nurse, and it was really quite frightening.

We had to think independently. If something happened, you immediately called your physician; but you immediately started what you felt needed to be done, whether it be getting an X-ray if someone fell, which they did because, if you're shot in the head and you're just waking up, you don't know one side is gone. So, you try to get out of bed. OK, 100 percent of the patients did that. You could put them in rails. You could put them however you wanted. These are young, healthy—with the exception of a terrible wound—men waking up not knowing that one side doesn't work. They'll climb over anything.

Krause continued talking about some of the patients she remembered the most:

One was a soldier who had a gunshot wound to the head, and it was a devastating one. Most of the time, these men would, within a week, be able to figure out how to walk. They'd figure out how to talk again. If they couldn't talk, they could communicate by writing. None of them had a total aphasia where they couldn't understand you. But this guy's wound was so devastating that he could not talk. He could not write. He could not tell you what he was thinking at all, but he could understand you.

He was due to go home. He'd been on our floor for awhile, and patients would stabilize and then go home for thirty days on convalescent leave. He was due to go home, and he was going home on a bus. He didn't want people to think that he was just a dummy. He could think as well as you and I. So I wrote a letter for him to bring that he could show from point to point that gave his name and told that he had been wounded in Vietnam but that he could understand everything and please help him to get from point to point.

He was ready to go off and do this, but it was very hard for him to face that. Well, the morning he was supposed to have been gone, by the time I came on duty, he was still there. He was sitting, looking devastated, and I said, "What's the matter?" Of course, he couldn't tell me, but amazingly, the men around him on this floor had figured it out. He had no medals. He had lost all his medals. He had lost his uniform. None of that had come back with him. When they figured it out, they got everything together. They all donated something, and they sent this guy off spit-spot polished, looking like the best soldier he could be, and he went off with a smile on his face. Off he went. I will never forget him.

Another patient was a gentleman who was in his late eighties; he had no family left at all. I think he lived in a boarding home; he was a little

disheveled. Not too many people wanted to take care of him. I was in charge that evening. I've always worked three to eleven. It was a respiratory floor, and he must have had pneumonia. But that's not why I remember him. He was lonely. He was my patient for the night. I went in. Everything was pretty much done for the evening, and I said, "Would you like to have a back rub?" And he just said, "Oh, I would love to have a back rub." I said, "Sure." I was giving him a back rub, and I said, "What did you do for your life? What did you do for a living?" He said he was in the military during World War II.

I said, "Oh, wow! I was an army nurse during the Vietnam War. I was at Walter Reed. What did you do?" This man poured out a story, unbelievable. He was with the 101ˢᵗ Airborne Division. He parachuted into—I have no idea where—but when he was parachuting in, he talked about how the enemy, the Germans, were shooting them out of the air, and he said, "All around me, my friends were getting shot. They were falling into the water. The water was bloody. I didn't know if I was going to make it down or not, and these were my buddies. We were very close."

He told me that story. He told me he had never told another soul about how they were all being shot out of the air. I thought, "Whoa!" and he started to cry. And I thought, "Oh, dear God, oh, my God," as he poured out this story to me. He had never told anybody, but he gave it to me. Oh, it was awesome. And now it's my story, and I can give it or I can hold it, you know? It's amazing! It's amazing! Your patients give you so much.

Krause continued to describe events that had happened when she was in school:

Well, there was a lot going on in the area when I was in school. This was in 1968, when I graduated, and that was when Bobby Kennedy and Martin Luther King were both assassinated. I graduated in June. They were assassinated prior to that.

When Martin Luther King was assassinated, there was rioting throughout the entire Washington, D.C. area. They burned Washington, D.C. They burned Baltimore, and it was a Friday. We didn't have cellphones. We didn't have CNN. We didn't have Fox TV. We didn't have twenty-four-hour news, and my roommate and I were going home. We lived outside of Washington, D.C. We were in Baltimore, and we were driving home, and we noticed that you could see this glow over the horizon over Washington, D.C. There was nobody on the roads.

We got to her mother's house, and her mother said, "Dear God, I've been petrified for you girls. Where have you been?" "Well, we were coming home. What is going on?" And she told us that there was rioting in Washington and that they were burning Washington because Martin Luther King had been assassinated. We were told not to come back because both Washington and Baltimore were under curfews. Because I was in the military, I had to have my papers with me at all times in case something happened. My roommate and I had an apartment; we didn't live on campus. Later, I did go back with my boyfriend, now my husband, to get my papers. When we drove into Baltimore, it was full of fog and smoke. It irritated your lungs. They burned Baltimore up to within a block of our apartment, but I was able to get my papers.

Krause compared her early years of practice to present-day technology. She noted there were no IV (intravenous infusion) pumps, no calculators, no plastic chest tube sets, no tests of arterial blood gases and no monitors of oxygen saturation. She continued:

Technology barely existed, and it sounds like I'm a dinosaur, but it was the Vietnam War that really brought in technology. I was on the cusp of it. I graduated and worked at Walter Reed. Then I left for twenty-two years because my army years were really very traumatic. I became a stay-at-home mom for all those years. I always had wanted to be a stay-at-home mom.

The technology is incredible, and what you have to do and what nursing is required to know is absolutely unreal compared to what we were required to know. However, having said that, you can lose the art of nursing in all of your technology because the art of nursing is: "How are you going to relate to that patient?" You can lose that if you're just looking at your machinery. So it's a double-edged sword. It's exciting to see, exciting to use. Your heads are doing far more medically than ours did at the time, but the patient can't get lost in that process. That's the most important piece. That's the art of nursing.

Krause had some advice for new nurses:

Nursing can be all-consuming, especially when you first start, but part of the problem is that you can lose yourself. You can lose your enjoyment of things outside. When you go home, part of the problem is, especially if something didn't go right on the floor, you tend to beat yourself up. You tend to think of it over and over and over again, ad nauseum. At some point,

you have to learn how to give that piece up and say, "I've learned my lesson." It's OK if you do make a mistake, but you've got to say, "I made a mistake." Then you have to forgive yourself for the mistake and go on. But you have to own up to those mistakes; don't try to hide them.

Beth Parks of Bangor graduated from nursing school in Washington, D.C. She worked from 1966 to 1967 in the operating rooms at the 7th Surgical Hospital and the 12th Evacuation Hospital in Cu Chi, Vietnam. She was part of the advance party that built the 12th Evacuation Hospital and was in a jungle area in the midst of some of the fiercest fighting of the war. Field hospitals in the area of Cu Chi served various units of the 25th Infantry Division, nicknamed "Tropic Lightning." The 7th Surgical Hospital moved to Xuan Loc in April 1967. Beth said that their mission at the 12th Evacuation Hospital was to provide hospitalization for all classes of patients within the combat zone:

The Vietnam experience was certainly like nothing else I've done in my nursing career. We did surgical procedures in Vietnam that a nurse would never do in the United States. I imagine there are veterans running around all over our country with scars that I made. We sewed up all kinds of stuff.

On November 10, 2013, in Veterans Day ceremonies, Parks joined military nursing colleagues in Washington, D.C., to attend the twentieth anniversary of the dedication of the Vietnam Women's Memorial. She and other veterans volunteered to read the one thousand names of their deceased co-workers at the anniversary ceremonies. Parks became an advocate for female veterans, especially supporting the importance of providing timely access to healthcare.

Myra Broadway was the executive director of the Maine State Board of Nursing at the time of her interview. She graduated from Hunter College with a BSN, an MSBA from Boston University, an MS from the University of Colorado and a JD from Franklin Pierce Law Center. After graduating from

her nursing program and receiving her RN, she worked at a VA Hospital and soon was persuaded by a recruiter to join the U.S. Air Force:

The first base I was at was Travis Air Force Base in California. Travis Air Force Base was the jumping-off base for Vietnam. I was dating a pilot at the time who flew in the Military Airlift Command, and they airlifted both troops and supplies in the C-140. So I was familiar with the terminology of "going over the pond" and coming back and forth because it was a supply type of a thing.

I remember one patient coming back on the air evacuation. I did not work air evacuation, but I went through the air evacuation building from time to time. I remember running into a young soldier; I was young at the time. He was in his wheelchair, and he was just spinning along. He was an amputee. I remember thinking, "He's been air evacuated back to the States." And we were the receiving facility because of the war being over the Pacific, so they always came back through Travis. He was wheeling, and he spun his wheelchair around and he said to me, "Hey, Lieutenant, you're beautiful." I remember being taken aback because I thought, "What in the world is he talking about? I'm not beautiful." And certainly the way I looked that day, I cannot imagine that. But years later, it occurred to me that what he meant was that I wasn't Sophia Loren or anybody then who was considered a real beauty. But what he thought was beautiful was the young nurse. I realized that when he said, "Hey, Lieutenant, you're beautiful," he meant the caring aspect that the nurse represented to him was particularly beautiful. So that's the story that stands out to me.

———

Elaine McCarty, who had worked in the 1950s with communicable diseases, went into the military because it was going to pay her a salary while she pursued her bachelor's degree. Her obligation to the military was to give back two years of service:

I gave them back two and a half years. First, I went to Hawaii and was stationed in Hawaii for a year, and then I went to Vietnam. I only had six months left on my time that I owed the army, so I had agreed to do the other six months because they weren't going to send me to Vietnam for just six months.

Vietnam. *Courtesy of Elaine McCarty.*

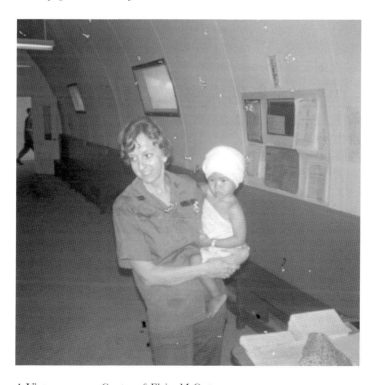

A Vietnam nurse. *Courtesy of Elaine McCarty.*

Elaine McCarty, army nurse, Vietnam. *Courtesy of Elaine McCarty.*

It's been hard for me to talk about my experiences in Vietnam...I don't mind so much anymore. It's that, unless you've actually done that yourself, it's too hard of an experience, at least for me, to transfer into words and say, "This is what it was." Either I'm just not clever enough with words, or I think there are some experiences that are hard to put into words that makes anybody grasp how it was. It's just beyond words unless somebody's been there. I think that is true about any really traumatic experience you have. Unless somebody else has done that, they don't fully understand. I don't think there are adequate words to describe it so that they'll understand.

When McCarty was discharged from the army, she completed a new master's program for adult nurse practitioners in Colorado. She came back to Maine and went to Deer Isle

> *to experiment with being a nurse practitioner down there where nobody knew what it was, including me, and nobody knew what they wanted the nurse practitioner to do. So I went, and I stayed there two years. Then I held a nurse practitioner job at Kezar Falls and then at Maine Med for about four years. Being a nurse practitioner gave me a sense of independence.*

Phil Meyers served in Vietnam soon after graduating from nursing school in New York State. Meyers's story described this journey and how he integrated his Vietnam experiences into his life:

> *At this time in my life, and at my next birthday, I'm going to be sixty-nine years old, and I'm still working. Looking back, I feel almost like I was born to do healthcare. I'm good at it, I enjoy my work, I continue to work because I enjoy it. It's been a wonderful part of my life. It's going to be hard to not do it. In fact, as I say that, it would be really hard!*

Meyers got a job as an operating room technician after graduating from high school in 1962 and made up his mind that he would go to nursing school and become a nurse anesthetist. Phil postponed his decision to become a nurse anesthetist for two years and enlisted in the army as a new graduate nurse and a brand-new father:

> *I graduated from nurses' training. I took my state boards. As soon as the results came back, I got orders to go on active duty. I was initially stationed at Fort Ord, which is in Monterey, California. It's right on the Pacific Ocean. I'm in New York, on the Atlantic, and I go three thousand miles to the Pacific with a one-year-long marriage and a new baby. We packed up the car and went to California. In fact, we drove right across the country. I ended up at Fort Ord as a general duty nurse. The hospital was about four hundred beds or so. Fort Ord was a basic training facility. There were approximately twenty thousand cadre who worked there, approximately twenty thousand basic trainees and a hospital to watch over those forty thousand people.*

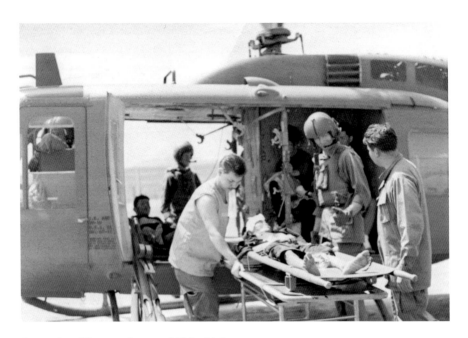

Evacuation, Vietnam. *Courtesy of Elaine McCarty.*

The Tet Offensive happened in February 1968. At that particular time, the United States sent over a whole new evacuation hospital. An evacuation hospital is about four hundred beds. They operate like a MASH unit, just like on TV. I was part of that hospital. Once the staff—the professional hospital staff—got in the country, it was about thirty days after the Tet Offensive. They took the staff who had been in the country a long time and knew what they were doing and spread them all over the country, and then they took the new staff and set up this new hospital.

The chief nurse at that particular time, who was a full-bird colonel, came and talked with all of us. They were looking to put people around in different places; they asked if anybody had any operating room experience, and I did. So I raised my hand, and I ended up in the operating room at the 12ʰ Evacuation Hospital. I was there from about the first of April until October 22, 1968. That's 201 days.

Meyers was able to talk about Vietnam only after helping his sister cope with her diagnosis of breast cancer. He explained that his sister, who was a nurse, wanted him to "just call her" and not talk clinically. Meyers called her every day for about a year and a half, and they talked. He listened as she talked about her experiences and her feelings. Sometimes she expressed fear,

anger and frustration, and other times, positive feelings. Meyers heard what it was like to be a patient in the healthcare system and felt it opened his eyes about how to treat people:

So that experience changed me. And it's related to Vietnam because, right at that same time, I started to remember some of the stuff that we did.

When I came back from Vietnam, I walked off the plane in Waterville, Maine. My wife was living with our two children in Waterville, which is where she's from. I had never seen my second daughter, Tracey; she was three months old. I walked off the plane. There was nobody there! And I'm talking about nobody! There was not a single soul at the airport. The plane landed, the door opened, I got off. It was one of these little DC-3 kind of jobbers from Boston. It was ten o'clock at night. There was zero people! No cars parked there. I got my stuff, and I walked into the terminal there. It was just a little, bitty place, and the plane turned around and took off. My wife showed up about ten minutes later. She had a couple of little kids, and I understood that, and I think the plane was a little early, too. But that's the way I came home from Vietnam. We never even talked about it. My parents never did. My siblings, people I worked with, we never discussed any of that.

I was already accepted into this anesthesia program. I spent several days decompressing, getting back into the world. Then, we eventually took off to Pennsylvania, where I was going to go into anesthesia training. That's where my Vietnam experience stopped. But recently, associated with my sister's breast cancer and how that way of thinking changed my life, I started thinking about some of the stuff that I had seen and had gone through. Those feelings came back, and it didn't bother me at all. I've cried in front of people before, and it really does not bother me that those feelings happen.

I normally wear a hat that says "Vietnam Veteran" on it. Because when you see people every now and then, the correct way to say something, if you want to say something to a Vietnam veteran because you happen to know they were there, all you do is say, "Welcome home." It affects people. It affects me.

Jim Allen, a staff nurse at EMMC at the time of his interview, grew up in Augusta. He shared some of his experiences of becoming a nurse in 1974 and how the Vietnam experience influenced his decision to be a nurse:

I was a corpsman in the navy; I got out of the navy in 1969 with a fair amount of medical knowledge and initially didn't really know what to do with that. Several of the guys that I knew, corpsmen who had also gotten off of active duty, had gone to Central Maine General Hospital in Lewiston to their two-year diploma program. They suggested, "Why didn't I come, too?" I said, "Well, I had no good reason not to." It sounded interesting. It's what I know. It's what I was interested in, so I went down to Lewiston and have really never looked back since then.

In Vietnam, we ran clinics for the military personnel on base, which included physicals, minor surgeries such as removal of sebaceous cysts, the removal of toenails, dispensing of some medications; these were pretty much a corpsman's responsibilities, with physicians overseeing those activities. At that point, with much fewer medications on the market, most of us knew all those medications and why we were giving them and what their primary side effects were. We felt confident with that information. It's overwhelming today, when you think of all the new medications on the market since 1970. But the experience in Vietnam was very good. We were fortunate enough to be able to go into the cities and hold clinics for the populace, and it was minor things like giving vaccinations, treating open sores, which a lot of them had. But this service was also good PR [public relations] *for us. It was a great experience. Coming back from Vietnam and getting out of the service, I had a fair amount of medical information, and it was nice to be able to put that experience to good use even though I knew that, as an RN, I would never do the same things that I was able to do while I was in the service.*

RURAL NURSING

Arna McNamee, a graduate of the Hartford Hospital diploma nursing program, moved to Maine with her husband, who had decided to move back to farm in Aroostook County in 1974. McNamee described the challenges of living and working in a rural community:

People usually think of rural areas as not being rich in resources and funding and not having much latitude in practice opportunities, but when you really look at it, it is a team effort up here…there is an excellent networking of members of the community, nursing, medical and emergency services.

People take pride in what they are doing, so they usually, being united, can accomplish more feats than in areas that do not have contacts and the network. It is a whole new, unique breed of people here. I think it was better for me to be here because I learned more. In order to get anywhere, you had to be your own motivator in pursuing what you wanted to do.

If you start out in a small, rural hospital and you work and get your basic nursing fundamentals down for what general medical-surgical nursing is, then you can choose an area that you really like and work another year on that and hone in on more intermediate and advanced skills. You'll find that in a small, rural hospital, you'll have to do a lot more things on your own. You don't have, as in other hospitals, people always doing this and that; such as, in a large hospital, you used to have an IV team come and draw your blood and respiratory therapist techs to do the treatments and EKGs and things like that. When you're in a rural hospital, those are the things you're doing. So you have a lot more opportunities to learn some skills, be integrated, become highly organized and know exactly what you've got for a team and be able to become efficient and work well with a small number of people. You have more opportunity to learn other areas, if you're motivated to do that. You also have to use critical thinking skills, problem solving, and you're forever evaluating whether it be a crisis or the way your whole shift was set up.

In terms of advising young nurses, McNamee stated:

No matter what your worst moments are, to deal with it, you're going to need a support network, whether it be good friends, whether they're in nursing or not. Always take some moments of your time to self-reflect on what you've done, what you could have done better, what worked well, what didn't work well, and then put it behind you and ask yourself, "Did I do the best I could do under those circumstances?"

Nursing to me is an art and a science. You have to have the love of science. You've got to have the love of people, and that's an art. You've got to have the gift to be able to communicate and give wholly and with a love and a passion for what you're doing. One thing about nursing is no two days are the same, no two shifts are the same, and I guess that's what makes nursing interesting.

Born in Farmington, Maine, Jan Bell went to nursing school and started working in Connecticut. She got married, started a family and then moved back to Maine to work in staff and leadership positions. She received her baccalaureate degree while working in her profession. Her story reflected her practice in a community hospital in rural Maine:

I worked and did my training at a thousand-bed hospital in Hartford, Connecticut. I entered nursing school in 1972. I came from my hometown of Farmington, Maine, and went to the big city. Of course, that was culture shock. I grew up on a farm, and we didn't have a lot financially. We had grown up with small financial resources, so we appreciated everything we had. We only got to go to town once in awhile, so here I go to the city to go to nursing school.

I came across my school bills not too long ago when I was going through some papers. I think, collectively for the three years, it was maybe $2,600. My mom had gotten some financial assistance. Because we weren't financially endowed, we qualified for some support. Then, between my freshman and sophomore year, when I came home for the summer—because we did have summers off—my mother entered me in the Maine Broiler Queen Festival because they offered a $400 scholarship. Now, she did all of this without my knowledge and told me when I got home, "Oh, by the way, I've entered you in the Maine State Broiler Queen Festival." I about died. I went down to Belfast, Maine. It was at the end of June when they had their broiler festival, and I did end up winning. There were fifteen of us, and I won. So I helped tuition that year by getting a $400 scholarship.

I was dating a man when I was at the end of my senior year in high school, and he was from Farmington as well. In my senior year of nursing school, he decided to move to Connecticut, and he started working at the University of Connecticut at Storrs. Because he did that, we said, "Let's just stay in Connecticut after we get married." I stayed down there for seven years. I worked at the hospital that I had graduated from. He wanted to come back and be a farmer. In the meantime, we had had three children. We moved back, and I became the nurse manager on a medical-surgical unit. I was only twenty-eight years old. I think back on that because today, to think somebody with only that many years of experience [could] become a manager, it's kind of daunting. "What was I thinking?" But I was an assistant manager at Hartford Hospital. I guess I've been one of those

people that was a leader. I am a first born, always telling my brothers and sisters what to do. I just gravitated always toward leadership roles.

Bell worked in the emergency room for ten years and was profoundly affected by patients and families with whom she worked. She talked about allowing a family member in the room when a loved one was being resuscitated during a cardiac arrest. In her experience, she felt that it helped the family member realize all the efforts that were being made to save the loved one, and it helped that the family member had the opportunity to be present to say goodbye if the person did not survive. Bell said of supporting the family: "It was really important and kind of goes to the core of why you wanted to become a nurse. It was that you could fill some little corner of their needs because it was so great a loss that they were experiencing."

ANA ROLE IN LEADERSHIP DEVELOPMENT

Nurse scholar Jo Ann Ashley noted, "Professional nursing must begin exerting open and public leadership...Nurses must change their own attitudes toward themselves and their role...from meeting the needs of hospitals and physicians to meeting those of the patient and the public."[57]

Margaret Ross was active at the state and national levels of the American Nurses Association. She came back to Maine in 1975 as the director of nursing at the CMMC in Lewiston. She felt that involvement in the ANA fostered leadership development:

When I worked in California, I had a marvelous director of nursing, and she said to the nursing body, "You are young, professional people; you are going, many of you, to be working in nursing all of your careers, and you should be taking part in your professional nursing association." We all nodded yes, and so she said, "I expect you to, and I encourage you to be on committees and become an officer if you want to and participate in the nursing organization." It was easy for us to get exposed to it, but it also gave us a chance to sample what kinds of committees we might be interested in, and we were given duty time or paid time to do it. That made it an expectation of your job that you took part in your professional organization in the manner in which you chose. So the expectation, plus the support of having the paid time to do it, encouraged nurses to do that.

Left: Doris Green, president of the MSNA, 1959–61. *Courtesy of MSNA.*

Below: An MSNA meeting. *Courtesy of MSNA.*

Ross felt that she experienced very supportive nursing leadership that expected nurses to have a voice in what their professional work lives were all about:

I think the professional nursing association participation has helped to develop nurse leaders and has helped them gain comfort and confidence in speaking about nursing and about the issues in nursing, whether it's about staffing or budgeting or even now, as we see it, with more and more influence in political arenas.

COLLECTIVE BARGAINING

Nurses had been able to organize economic security programs through the Taft-Hartley Act of 1947. However, they were not allowed to unionize at nonprofit hospitals until labor laws changed in 1974. After this change, many unions began to compete with the ANA for recruitment of members, "prompting ANA to engage in collective bargaining."[58]

During the 1970s, the Maine State Nurses Association (MSNA) formed a collective bargaining unit at EMMC. During the formation of the collective bargaining unit, the division between those nurses who sought to achieve change through collective bargaining and those who sought to achieve change by influencing health policy in both the public and private sectors created a split in the MSNA's leadership. However, the majority of the MSNA's leadership remained committed to securing collective bargaining rights for nurses.

Anna Gilmore, director of the MSNA's Commission on Economic and General Welfare (EGW) in the late 1980s, spoke about collective voices: "Lend us your energy, creativity and time to make that collective voice strong and complete in Maine."[59] These words were in the forefront of nurses' minds; they believed collective bargaining was the answer to their expressed concerns about the treatment of nurses and the nursing care of patients.

Phyllis Healy, president of the MSNA, 1986–88. *Courtesy of MSNA.*

The EGW had functioned for many years before unionization became an issue. As collective bargaining began, the commission provided guidance to staff nurses seeking to organize. Nancy Chandler served as director of this commission during the early years of collective bargaining in Maine. Chandler received her nursing education at Bates College, graduating in 1957. She recalled when she was part-time director of the EGW:

> That's when I got involved with the nurses at EMMC. They wanted to organize into a union. I started going up there and meeting with the nurses and learning bit by bit about labor organizing. I didn't know much as I had never been involved with it at all, so I had some help from some other labor organizers in Maine, as I did realize that there was a real need for them to organize. They weren't organizing for financial issues. They were organizing for patient care and safety issues.

Chandler noted that because the union was part of the ANA, it posed a problem for many in management positions to maintain their MSNA memberships, but most did. She continued:

> We organized, I think, in 1975 or 1976, when they had their election... we were seven years in getting a contract. We did not know what to do, so ANA stepped in. They sent a person to help me get going. Once I realized that all you had to do was to know what the nurses wanted and how the hospital worked...so the ANA organizer came a few times, but after that, I did the negotiating.

Chandler became executive director at the MSNA in 1976 and stayed in that role for ten years. Polly Campbell became the first full-time EGW director in 1982 and worked for the MSNA for four years. She graduated in 1969 from the State University of New York at the Upstate Medical Center. Campbell emphasized that Chandler's work with union activities secured quality of care and set the standard for pay for nurses in Maine:

> I was director during the second and third rounds of negotiations at EMMC. It was such an exciting time for the nurses because they recognized their power, not only as nurses, but as women. The ratification of the EMMC contract set the stage for nurses across the state to begin their own organizing activities over the next several decades.

A collective bargaining celebration. *Courtesy of MSNA.*

Dottie Barron experienced the early formation of a collective bargaining unit. A staff nurse at EMMC for thirty-five years, she described the development of the first nursing union in the state of Maine:

Oh, gosh. A funny thing is, long before I ever heard anybody say anything, I said, "What we need around here is a union." Staffing became a big thing—having enough RNs to do what they wanted the RNs to do. None of us really knew what to do in the beginning. The American Nurses Association sent people to help us, figure out what we needed and how to get things going, how to get organized. We received a lot of help from other unions in the area. They were very helpful in terms of meeting with us about organizing and letting us use facilities for free. We had no money. It takes a lot of work, a lot of energy. There are things you can do at work, things you can't do at work, like putting up a notice of a meeting. Then you have to let the hospital know that there's union activity. That gives us some protection. All the notices were on the backs of the bathroom doors because that was a non–patient care area. The hospital was growing, and so was the number of people you had to find to get informed.

It was a lot of years, a lot of meetings. We went through a whole lot of legal things that I'd never heard of—the court systems and the National Labor Relations Board officials in Washington, D.C., and the court hearings with them. I was one of the witnesses in the court hearings. If you thought one side or the other had done something wrong, you had to file a grievance with the National Labor Relations Board; they sent people in to investigate, and then they interviewed everybody involved on both sides. It took a lot of hard work. Our first contract was in June 1982. I think the first informal meeting about unionizing was in 1974 or 1975.

I became very active in my local unit, and eventually I was in a position where I was involved as the head of a committee statewide that organized all the other bargaining units around the state of Maine. I sat on the board of the Maine State Nurses Association for a good many years. I'm trying to think when we finally broke apart. We voted to have MSNA organize and not be a part of ANA.

After the MSNA left the ANA, non-union nurses wanted to continue their affiliation with their professional organization, ANA. In 2001, these nurses formed ANA-Maine as the constituent assembly of the Amercian Nurses Association. The MSNA continued its union function.

Barron continued talking about nursing unions and her career:

Nurses don't go into nursing to learn politics and legal stuff; we go in for the care of our patients and to try to make a better outcome of people's lives. For me, on a personal basis, the objective was getting a contract. I did a lot of hard work and invested a lot of time for something I believed in, and I went through a lot of stuff. I think signing that first contract for me was one of the highlights of my career. I felt like I'd fought for nursing and nursing rights. I fought for making it better for patients—for example, more nursing, better education. I always said to people, "If you have a good administration, your nurses won't want to organize."

HOSPICE

Pat Eye's career spanned over sixty years of nursing practice. Eye graduated from Eastern Maine Medical Center in 1953. She married, had children and traveled the world with her husband, who served as a

diplomat. Eventually, Eye used her own funding to establish New Hope Hospice in Maine:

I always wanted to be a nurse ever since I could remember. That was back in the diploma days, in the three-year nursing program days. Everywhere I went in the world, I was able to do something in nursing, in both underdeveloped countries and in developed countries. It's just been a part of my life. My first country was Burma (Myanmar). I had to go visit the ambassador's wife, who happened to be a social worker. She wanted to know what my skills and interests were, and I told her. She introduced me to a missionary couple. One was a physician, and the other was a teacher. They had a little place out in Okalapa, way out in the wily wags from Rangoon. He ran a clinic two or three times a week and said he would love to have me. So I took a real crash course in Burmese. The only Burmese I knew was just medical questions: Do you have any worms? Have you been vomiting? What are your stools like? Those kind of things. But it was so rewarding. We didn't have any electricity. We reused needles that were supposed to be, at that time, disposable, but we sharpened them and reused them. I saw everything. I saw beri-beri, which you wouldn't think of seeing in a country that had plenty of food hanging off the trees. But it was like a lot of diseases that I would never in my life have seen, like leprosy. There was a leper colony that I went to where I saw people who were really debilitated from having lost digits and limbs who were in their own community. They all had jobs to do, and they were doing reasonably OK. But they were away from the general community.

The experience was great. The doctor that I worked with was just wonderful. We would see anywhere upward of eighty to one hundred people a day, and it was in just a little shack. I think of it now...but it was good, and we did what we could, and we made lives better.

The next underdeveloped country for me was Vietnam. In Vietnam, General Westmoreland's wife was a real mover and shaker and saw that things needed to be better medically for people. There was an orphanage, and they really didn't know how to keep unwell babies away from well babies. There was a lot of cross-contamination. I had gotten a little group of nurses together, and we would have classes with the people who ran the orphanage. Mrs. Westmoreland was planning to build a new place because it was well needed. Did it ever get built? I don't know because we were all evacuated from Vietnam after the Tonkin Gulf incident, but it was a wonderful experience.

After Vietnam, Eye went to Switzerland. She spoke French well and volunteered in a hospital and for the Red Cross. Following that, she traveled back to Southeast Asia:

The next country was Indonesia. I spoke really excellent Indonesian. The Naval Research Unit came to Indonesia to do a test on schistosomiasis. Now, there's only a couple of places where this exists. And so we went up to Sulawesi. We were down at a base camp, and then we went up in the mountains on a narrow pathway on the back of ponies. I was sliding off, and the guide said, "My sister! Move up, sister!" pushing me with both hands on my backside. But I didn't mind because...Oh, if you looked down, it was straight down. It was all jungly, but you knew that it was a sharp drop-off. My job was to translate, and we would do proctoscopes. That was to do biopsies to see if they had schistosomiasis.

After coming back to the United States, Eye had two experiences that she perceived as life changing and that served as directives to where she went in nursing after that. One involved the death of a young adult whose family forbade anyone from telling the patient about his impending death. The second involved a dying patient sent to the special care unit whose death was not peaceful. Eye said, "So those two experiences set me up to get into the work that I do today."

While Eye's husband was stationed in Washington, D.C., she nursed terminally ill children, some with Tay-Sachs disease, some with other conditions, but there was an established population at that institution. Around this time, Eye related the following story about how a television program influenced her direction in nursing:

It was a Barbara Walters program, Not for Women Only, and usually there was a weeklong series. Well, this particular week, it was on death and dying. I watched every part of it. Elizabeth Kübler-Ross was on the panel. And if you asked me who else was on the panel, I could not tell you. I thought, "Oh, this is it. This is how it needs to be done." She realized that people needed to process, they needed to talk. They were ready and willing to talk. We knew about it out at our little clinic, and we sort of had a little hospice-like therapy group for our little kids. What was hard about that was that the kids were fine. That was just a beautiful thing. But the parents, the poor parents, they were in a world of hurt. Should they wish for this child, who is suffering—and some of them were suffering—should

they wish for them to have peace and have it be at an end? Loaded with guilt because this was an imperfect so-called child, and they were wishing that child dead, they needed us more than anything. But that was all intertwined with end of life and Kübler-Ross. Then I got her book on death and dying, which further inspired me.

Eye's first hospice patient had terrific pain. She continued to describe her experiences:

This is where I first began learning about the value of medicating these folks around the clock. The patient had a solution of morphine and cocaine. We all must remember that twenty years prior to this, in England, they already had a hospice, and Twycross had written the book on that subject. The book was only about a half inch thick. Everything we knew about pain management for end of life was in that book. The goal of drug combinations such as morphine and cocaine was to provide pain relief without sedation. In England, the hospice movement's use of these medications had allowed patients to participate in meaningful activities during their remaining time in hospice care.

When Eye went with her husband to Hawaii, she described the hospice movement there:

Hospice was in full bloom there, so I helped Sister Francine continue to set that up as a volunteer. This was in the late 1970s. When I came back to Maine, the people here knew nothing about around-the-clock medicating. I had to start from scratch again. Two physicians helped me with that. I would get the physician to order the medication around the clock, no exception. I would figure out what they would need and come back the next day, and whoever had been on night duty would get the order changed back because they didn't want to be the nurse that killed the patient. There were a lot of barriers in those days. We didn't have the array of choices of medications and routes that we have today. It's marvelous today. But those two doctors helped get that started. I had to do a lot of teaching with nurses. They just couldn't get it because it was antithetical to anything they had ever known. But it worked. It finally worked

The hospice concept grew in Maine, and soon Eye was asked to consult all over the state. When nurses came to interview, Eye said, "I can teach you

anything that you need to know clinically, but you need to come to me with a heart and soul, and that heart and soul needs to be part of what you're doing here. A major part."

New Hope Hospice was founded in 1994 by Patricia Eye, Constance Eye and Nancy Burgess as an in-patient hospice facility:[60]

That's what keeps me going today, eighty-one, still working full time, running my little show there. We're small. I like the intimacy of twenty or thirty patients, that's enough. If they're spiritually and emotionally distressed, we're not going to do anything with that until pain is managed. We've had some really super experiences with good pain management, teaching families and symptom control. I tell them up front, there are two symptoms that we're not going to be able to help you with, fatigue and weakness, because that's part of the process. But we can teach you how to pace yourself, if you can learn that. If you've always been a doer, that's a hard learning process. It's just every day is different. It's so rewarding, I cannot tell you. I couldn't continue to do it if it were just a job. I just couldn't. There are surprises, there's sadness, there's triumphs; all of that, all of life experiences, that just makes me stay with it.

I think nurses are going to have to be advocates. I think they're going to have to advocate for the patient in every way possible. But they're also going to have to be advocates for medical care, good medical care. I think that's going to be a huge challenge.

During the 1960s and '70s, nursing met the challenges of new roles and responsibilities in the cacophony of changes in those years. Many men entered nursing after the Vietnam War and established a strong and respected role in the profession. Nurse anesthetists and nurse practitioners in Maine provided varied services to many medically underserved people of Maine. Nurses continued to demonstrate caring and competence.

Chapter 5

ERA OF HEALTHCARE REFORM
AND COST CONTAINMENT

1980–1999

Voices of nurses in the 1980s spoke about the changes in the traditional role of nursing as nurses participated in evolving systems of healthcare management, cost controls, higher education, research and theory development. Nurses maintained their focus on providing compassionate care for all, including those marginalized by poverty, illness and social stigma.

AIDS (ACQUIRED IMMUNE DEFICIENCY SYNDROME)

On June 5, 1981, the U.S. Centers for Disease Control (CDC) published an article in *Morbidity and Mortality Weekly Report* (*MMWR*) describing cases of a rare lung infection, pneumocystis carinii pneumonia (PCP), in five young, previously healthy gay men in Los Angeles. All of the men had other unusual infections as well, indicating that their immune systems were non-functioning; two had died by the time the report was published. This was the first official reporting of what would become the AIDS epidemic.[61]

Initially, it was not known what caused the disease or how it spread, but it appeared to be a rapidly fatal disease of gay men. Fear was common and difficult to overcome, even as knowledge started to progress. It soon was identified that AIDS was caused by the human immunodeficiency virus (HIV), which was transmitted by exposure to blood and bodily fluids. This

Louise Davis, advance practice nurse. *Courtesy of Louise Davis.*

was not just a disease of gay men; all were susceptible to it.[62] The growing incidence of AIDS rallied nurses to provide both compassionate care and education about preventive interventions to stop the spread of the disease.

Louise Davis was an AIDS prevention educator and was on the front lines of nurse educators during the 1980s epidemic response when she worked as a nurse in Portland, Maine:

> *If, while in nursing school in 1962, I had seen a video of myself standing on the stage in a high school auditorium some twenty-five years later, slowly putting a condom on a banana while explaining how to do this properly, I certainly would have been baffled by my actions. Yet there I was, up there on my own, working to strike just the right balance with these Maine high school seniors between, on the one hand, making them believe that having unprotected sex could easily lead to their death and, on the other hand, scaring them so much they'd stop listening.*
>
> *I developed a curriculum based on the scant literature and the one movie short available and went around to high schools in the Greater Portland area presenting AIDS information to seniors in high school. There were many more principals who felt they just couldn't risk all the negative reactions such a presentation might provoke than courageous ones who took a chance. I believed then, as I still do, that my being a nurse was what got me in the door. People respected and trusted nurses,*

and that extended to the principals, the students and, according to the feedback I got, the parents.

Being a nurse was also an advantage when I worked answering the phone at the AIDS Project, an organization formed in southern Maine, early on in the epidemic. In the beginning stages of the epidemic, there were a number of misconceptions and questions about what caused AIDS and how it was spread. Because gay men were the first group identified as having something (an especially unusual type of pneumonia and Kaposi's sarcoma), for a time, male homosexuality was implicated. But, by the mid-'80s, the human immunodeficiency virus had been identified, and AIDS projects were springing up all over the United States. Our headquarters was in one of those lovely old downtown Portland buildings that was originally a residence. On this relatively quiet street, we volunteers worked with the first wave of HIV-positive patients and many more people who feared they might be HIV positive. Because I was a nurse, I was one of the go-to volunteers who knew most of the answers then available to the questions about AIDS. I talked with other volunteers, new patients, panicked members of the public who'd had unprotected sex and others who wanted to be sexually active and needed information on how to protect themselves. I counseled drop-in visitors and those who called our hotline. I sent people to be tested, helped them understand when and how they would learn the results and quickly learned that saying I was a nurse lent me credibility when I unequivocally told people: "Yes, you must use a spermicidal cream, jelly or foam containing nonoxynol-9 with a condom" or "Yes, you must use a condom every time" or "The only sure way to know is to get an HIV blood test."

Understand, in those early days of the epidemic, no one spoke of people living with HIV as they do now. There was no routine screening, virtually no early detection, no drug cocktails and no long-term living with AIDS. Patients were diagnosed when they developed one of the common opportunistic illnesses, and almost always, they died very quickly. I was appalled by the rapidity of the process when a person's immune system was severely compromised.

Early in the 1980s, the AIDS crisis, as inevitably happens with important and controversial issues, raised emotions and social mores about homosexuality, and it tended to cloud the main goals—in this case, improving the physical and emotional treatment of those afflicted. Thank goodness, by the time I ended my involvement and returned my private practice to full time, there were many people who were volunteering in a number of areas. While research had revolutionized treatment, money was raised to pay for more research, for extensive education and for the care of an ever-expanding patient population. The response was a reminder to me both of what can

be accomplished when many work together and of my gratitude for having
a credential as a registered nurse that everyone recognized. That enabled me
to be a small part of this historic healthcare work.

———

Terry Clifford talked about her work with people with AIDS and HIV prevention. Clifford always knew she wanted to be a nurse. Growing up in Rumford, she chose the nursing program at what was then called the University of Maine at Portland-Gorham. She received her BSN in 1981 and a master's degree in 1991. She remained primarily at Mercy throughout her career, working on most of the units and serving as supervisor and clinical advisor. Post-anesthesia recovery care was her specialty. She went on three international mission trips to provide healthcare in areas of high need. Clifford became involved in AIDS care during a clinical placement while she was in graduate school. She recalled:

> *I ended up becoming an HIV counselor, doing anonymous testing for both the*
> *AIDS Project and the city for two years, during which I was getting my degree.*
> *It's best when you're in a program like that to really focus in one area, so I took*
> *that advice and focused on the HIV world and became quite involved.*
>
> *My graduate project was working with one HIV educator on the streets*
> *who was funded by a federal grant through the State of Maine, and he*
> *worked both here in Portland and in Lewiston. Two days a week, he was*
> *in Lewiston; two days a week, he was in Portland. He walked around with*
> *a backpack that was full of supplies for the clients on the street. Everybody*
> *knew who he was, and they would stop him on the street and ask him*
> *for supplies to clean their needle works. Whatever they needed, he had it*
> *in that backpack. I spent part of my graduate project doing experiential*
> *observation, working with him on the streets and learning about the culture*
> *that supported him to do that work, and it was really very interesting.*

Working at Mercy Hospital in the late 1980s, Clifford and Paul Chamberland developed a Maine chapter of the national organization Nurses in AIDS Care, thus furthering HIV education and HIV outreach in the state of Maine.

HEALTHCARE REFORM

During the 1960s and '70s, increased access to care and developing technology expanded healthcare costs.[63] These changes brought about public policy focused more on healthcare management than on disease control. The model of managed care was to keep people well and to decrease costs by effective and efficient use of resources. In response to the growing cost of hospitalizations, in 1983, Medicare introduced the Prospective Payment System based on Diagnosis Related Groups (DRGs). The purpose of this system was to provide incentive for hospitals to offer efficient and effective care that decreased length of patient stays and thus reduced costs.[64] In these years, healthcare resembled a business rather than a professional service. Managed care and the DRG system resulted in challenges and opportunities for nurses. Patients were discharged from the hospitals more quickly and sicker, and more patients were referred to community health agencies or long-term care facilities to recover.

Helen Genco, a nurse leader in Bangor, was one of the pioneers of Maine's home care and visiting nurse services. Her story reflected changes in community health agencies related to the healthcare reform initiatives of the era. Genco grew up in Ohio and obtained a BSN and a master's degree before moving to Maine with her husband and two small children. After arriving in Maine in 1975, she was hired for a position as instructor at a diploma school:

> *In 1978, I went to graduate school for my master's degree in business administration (MBA) at the University of Maine. I finished in 1984 and started at Bangor District Nursing, which is now Bangor Area Visiting Nurses, as the administrator. The EMMC diploma nursing program ended in 1985. I had a year left when it ended and had transitioned away from nursing education into the practice or the service end of it, which I enjoyed. It was really more my cup of tea because you had a variety of ever-changing issues to deal with: regulatory, billing, human resources, service delivery, policy writing, working with a board of directors. I really enjoyed all of that. I mean, there was never a dull moment.*
>
> *I worked as leader of the Bangor Area Visiting Nurses from August 1984 until May 2008. My titles changed, but the position was always the same. First, it was as administrator, and when I began, we had thirteen employees. We were in a little blue house, the gatehouse of the Wing Park Estate, and Wing Park is that big yellow house across from the hospital at*

EMMC. The original building was, I think, only seven hundred square feet. It was really something.

Back in 1984, we did not have any computers in the home care office. We had one typewriter that had memory—I think a hundred words, or something. We thought we had died and went to heaven with that. So technology certainly transitioned quite rapidly between 1984 and when I left in 2008. Nurses went from handwritten notes about their home visits to having an electronic medical record (EMR), which we acquired in 2002.

The kinds of changes I think about when looking back are recalling when Medicare kicked in and when the end stage renal disease benefit kicked in. That meant hemodialysis could be developed and readily available to those who qualified for that benefit. I saw IV bottles transition from glass to plastic bags. We never had the little pumps until probably in the late '80s, early '90s. Glass syringes, yes, I saw that transition, too.

When I got to Bangor Area Visiting Nurses in 1984, like I said, we had thirteen employees; five of them were nurses, I think several were home health aides and then the rest were office staff. Things were pretty easy, pretty uncomplicated back then because Medicare had kind of looked the other way at home care. It wasn't a big expense to them...We found ourselves asking how we could maximize what we could do for our customers, the patients, because they were living alone, usually, and it was a way to keep them out of institutions. Our home health aide services were actually doing twice-a-day, seven-days-a-week visits, which now you would not be doing that at all. It was our way of seeing that people got their meals, got to the bathroom and that we made sure their environment was safe. We did quite a lot of that, but by the mid-'90s, that had changed.

Genco talked about the agency's first patient with intravenous therapy in the home and the amount of training the nursing staff needed to provide quality care. Complexity of care in the home setting increased as patients were discharged to home with complex needs requiring skills and technology that formerly had been seen only in the acute care setting. In response to rapidly growing costs, the Balanced Budget Act of 1997 placed home care under a prospective payment system, which limited the type and amount of visits reimbursable.[65]

NURSING EDUCATION

Nursing education in Maine was changing. MSNA's *Annual Report: 1960–1961* recorded the University of Maine–Orono as the only nursing degree program and listed only five hospital-affiliated nursing schools approved by the Maine State Board of Nursing.[66] By 1976, three associate degree programs had opened: Central Maine General Hospital School of Nursing in Lewiston, University of Maine in Augusta and Westbrook College Department of Nursing Education.[67] When Central Maine Medical Center received state approval to grant an associate degree in 1976, it was the first of its kind in New England and only the fourth in the nation.[68] By the end of the 1970s, there were two baccalaureate degree nursing programs: Saint Joseph's College Department of Nursing in Standish and the University of Maine School of Nursing at Portland-Gorham. In 1985, Saint Mary's in Lewiston was the last diploma school in Maine to close.

In 1983, the MSNA received a grant from the ANA for a proposal to make the baccalaureate degree the basis for professional nursing practice.[69] The Maine Statewide Task Force on Entry into Nursing Practice developed recommendations to include educational requirements for two levels of licensure into nursing: the associate degree of nursing and the bachelor

The initial nursing faculty at Saint Joseph's College (SJC). *Courtesy of Elaine McCarty.*

The Health Assessment Lab, SJC. *Courtesy of Elaine McCarty.*

SJC students, 1990s. *Courtesy of Elaine McCarty.*

degree nurse. A grandfather clause would ensure that those licensed prior to the change would retain their original Maine licenses.[70] In 1986, Maine governor Joseph E. Brennan signed a bill stating that by 1995, there would be two levels of nursing.[71] Although this bill passed and was signed into law, it was never implemented.

Judy Stone was a faculty member at the University of Maine at Portland-Gorham before becoming vice-president for nursing at Maine Medical Center (MMC). Stone was born in Maine and went to the University of Maine–Orono for her nursing education. She was introduced to nursing as a small child when she helped care for her eldest sister, who had rheumatic fever. She said both of her parents were caregivers, particularly her father:

As I went through high school, it was an era where the options for women were not all that broad, and so I just naturally chose to go into nursing. But I knew I wanted to go to college. My oldest sister had graduated from Orono, and so I decided that since they had a nursing program, I would choose to explore that as an option, and I did because it was the only baccalaureate option in the state. Colby had closed theirs. They had had one, but they had closed theirs.

What nursing has meant to me in the context of my life is that it was certainly very central to my life. I probably found myself, once I had finished college and worked in Boston a year. One of my classmates from Orono and I had already concluded that we were going to grad school, and we went to Penn. From there on, I was very career focused. I was very focused on the work of nursing.

We went to grad school and majored in medical-surgical nursing and administration. My passion was gerontology. When I was finishing grad school, I thought that was the direction I wanted to go. Well, I started interviewing, and nowhere in the realm of gerontology or geriatrics or elder care was anyone prepared to hire someone educated. So I went to work at Pennsylvania Hospital at Eighth and Spruce as a supervisor and developed the coronary care unit and supervised the special care unit, emergency room and the medical-surgery units. Other than gerontology, medicine-surgery was the core of my love. I just felt that that was generic to all nursing.

I worked there for a while, came back to Maine, taught for the university for eleven years and did three years as dean. Miss MacLean, from the University of Maine at Orono, had called me every year since I had graduated to ask me to come back and teach. I kept saying, "No, I'm a practicing nurse; I'm not a teaching nurse." So she called me, and she said, "Judy, this is going to be my last year as the director of the school. Everything is going to start being centralized in Portland, and that's where you would be based because that's where the clinical stuff is." I came back in the fall of 1968. She had really been a great mentor. You didn't think so when you were a student, but you appreciated it later in that there were a lot of very sound teachings in what she had to say. She always made an ongoing kind of investment in many of us. So when I came back, she was director, and Anna Ivanisin was the Portland-based coordinator. We were all based at Vaughan Street in what's now McGeachey Hall.

We had feeder programs from Orono, Presque Isle and Portland. I think Mary Ann Eels came in 1969 or in the fall of 1970 as the first dean that was bringing the school together. Before Dr. Eels came, they were sending students down here just for clinicals. That was what Anna Ivanisin and some of the other faculty did. They were treating it more like a satellite because when I went through the program, I had my medical-surgical nursing at Eastern Maine, I had my pediatrics and OB here at Maine Med, I had rehabilitation at Thayer in Waterville and psychiatry at Boston State Hospital. I had public health, or community health, out of one of the state offices in Lewiston. We moved often.

After serving as dean for three years, Stone went on sabbatical and was recruited by Agnes Flaherty to Maine Medical Center, eventually to serve as vice-president for nursing. Before retiring, she expressed frustration with the focus on the bottom line in healthcare: "I found that frustrating both in terms of the patient perspective and also from the staff perspective." After retirement, Stone continued to work on enhancing elder care in the hospital and helped to develop what has become the Partnership for Healthy Aging within Maine Health.

Nancy Greenleaf was dean of the nursing program at the University of Southern Maine during the discussion of entry into practice issues and when

the University of Southern Maine developed the state's first master's degree program in nursing. Greenleaf was born in New Hampshire and graduated from the Mary Hitchcock School of Nursing in Hanover, New Hampshire, in 1958. She obtained her BSN, master's and doctorate from Boston University (BU). In her story, she talked about her education and her role as dean:

> My friends, many of whom I'd gone to school with, seemed to all get married, and I didn't. So I came back to Boston and decided. I remember the moment; I was putting the bedpan into the hopper when I thought, "I think I'm going to go back to school." There was something about the routine of that that was important.
>
> I found out that if I worked at Mass General full time, they would pay half time; they would pay for me to go to BU. I did that. I came back to Boston in 1962, and I got my baccalaureate degree in 1964.

In 1982, Greenleaf described how she and her husband made a decision to move to Maine:

> My husband was working at one of the high-tech places on Route 128 in Boston. As a mechanical engineer, he was inventing lots of things and had a good career, but he felt like the work they were doing was either going in the circular file, which is the wastebasket, or it was military, and he didn't feel comfortable with that. So he said to me as I was getting near the end of my doctoral program, "Why don't you see if you can get a job in Maine because I'd like to do some organic farming!"

Greenleaf eventually accepted a position teaching in the nursing program at the University of Southern Maine in Portland and Gorham. She had studied economics in her doctoral program and was also very interested in women's work. At that time, the University of Southern Maine baccalaureate degree nursing program had two satellites: one in Fort Kent and the other one at the University of Maine in Orono. Greenleaf observed:

> Every campus wanted everything. They particularly wanted nursing. When I became dean, I looked at this. I have to tell you this little story. I went to a seminar. It was out in Colorado. There's an organization for deans of collegiate programs, AACN [American Academy for Collegiate Nursing], and I went to one of their meetings. They had a seminar for

new deans where we sat around with old hats who could tell us how to do our jobs. We introduced ourselves, and when I said, "I'm the dean in Portland, Maine, and we're extended to Orono and Fort Kent. By the way, Fort Kent is the same distance from Portland as Baltimore, Maryland, just to give you a sense of space. Then there're these associate degree programs that are also under me. I'd welcome any help you can give me." I'm saying this to experienced deans, and one who was very well known looked at me and said, "It's too late. You're beyond help."

At that time, Greenleaf described how faculty would fly in from Fort Kent and drive down to Portland from Orono for faculty meetings:

Sometimes, we took a bus and drove the faculty. I had to fund all this travel. I went to the president, finally, and said, "You know, you wouldn't do this to a business school. They'd have a leader on each campus where there was a business school. And you don't do it to the school of education, either. Are you doing this to us because we're women?" And essentially, what I did in my five years as dean was to dismantle that, and I got a leader, a nursing leader, at each of those campuses.

A master's degree in nursing was being developed while Greenleaf was at USM. She inherited the program after being at the university for only two years:

It was sort of a nontraditional master's program. It was very forward thinking. I was trying to survive as dean and get somebody to become the undergraduate program director to run the graduate program. Meanwhile, I was trying to figure out how these campuses worked. Some consultation help came from Boston. It was especially important to receive National League for Nursing (NLN) accreditation for the master's program.

Greenleaf's responsibility was to meet with the NLN in New York to represent the master's program during the accreditation process. It was the first master's program in nursing in the state. When the program did not initially receive NLN accreditation, it was a huge disappointment. However, nationally recognized experts were brought in as consultants. Part of the recommendations of the consultants was to resolve the problem of multiple campuses; this was a difficult process, but it was resolved. After the satellite programs were ended, the USM master's program finally received the

required accreditation. Greenleaf concluded, "We brought in good people. We brought in good consultation. We practiced our presentations. We did everything, and we got through."

NURSING THEORY AND RESEARCH

Jacqueline Fawcett is an internationally known scholar and member of the American Academy of Nursing whose work has advanced the development of nursing as a profession. Her writings and research helped establish nursing curriculum as a unique body of knowledge and clarified the relationships among concepts, conceptual models, theory development, research and practice. Fawcett received her BSN from Boston College in 1964. She received an MA degree in parent-child nursing from New York University (NYU) in 1970 and her PhD in nursing from NYU in 1976.

Fawcett lives in Maine and has shared her knowledge and skill with Maine nurses. She served as an adjunct faculty member for two years at Husson College and was a Libra Foundation visiting professor at the University of Maine at Fort Kent in 2001. She was chair of the Research Committee of MSNA from 1998 to 2001 and presented several research roundtables at no cost for members at different locations around the state. She wrote a series of articles for the *ANA-Maine Journal's* Research Corner in 2010. Fawcett said:

> *I regard myself as an ordinary person who has had many extraordinary opportunities. Being a nurse has been a fantastic experience for me. I can't imagine having another career in which I could have attained so many goals and done so much satisfying work. I came back to the University of Connecticut to teach the year that I was finishing up my dissertation. I stayed there for three years. Toward the spring of the third year, I was recruited by my dissertation chair, who had subsequently moved to the University of Pennsylvania, so I started teaching at Penn, and I stayed there for twenty-one years. Then we moved to Maine, and I commuted for another couple of years. I had seen an ad for a position at the University of Massachusetts–Boston in their new doctoral program that had been around for a couple of years, and they wanted somebody to teach in the doctoral program and to do faculty development, which I'd been doing informally at Penn. I interviewed, and I got that job. I'm starting my fifteenth year there. So that's been my career.*

Fawcett was active in ANA, and when she moved to Maine, she changed her membership to MSNA. She felt that

> *it would be a really good way to get to know nurses in Maine. My first year, I was still at Penn, so for three years I was essentially associated with Penn. And I didn't know anybody in Maine other than one or two people I knew socially. But I didn't know any nurses in Maine, and I thought that would be a good way to get involved.*
>
> *The ANA went through a difficult time when the union came in, and we split off. I remember vividly how difficult that convention was and how disenfranchised I was from those nurses who wanted to unionize. And I was glad that we formulated ANA Maine.*

In reference to her research, Fawcett continued:

> *What I do is always for the sake of practice. I mean, why do research if it's not eventually, if not sooner than eventually, for practice? I learn a great deal from my students, and when I taught in a diploma program, and when I taught in a baccalaureate program and even now, when I teach in graduate programs, I learn a great deal about practice by listening to my students. I talk to them about how practice could be so much better if we used nursing models and theories to guide our practice. You need to be absolutely committed to nursing, to use a nursing conceptual model as a guide for practice and research and everything else that you do, to be fair and fearless, to be assertive and not aggressive, to stand up for what you know is right. And, I think, take* risks. *If you take a risk and you are not rewarded for taking that risk, if you're essentially chastised, or whatever the right word might be, then leave that place. Never stay in a place where it's not the right place for you. No matter what.*
>
> *Keep in mind that you can be any place that you want to be, and your family can be in another place, and it does work. Granted, we chose not to have children, so that made it easier for me. But my husband and I have talked about it repeatedly, and he said, "You would have done what you did. You would have gone away to school, you would have gone away to work, no matter what. We would've found ways to take care of the children." When people say, "I don't have the choice because I live here, and I can't be there," I say, "No, you have a choice, and you made a choice not to move and not to do something else." You can do that. I'm a living example of that.*

If we survive as a discipline and a profession, and I'm not convinced that we will, then the challenge is to use our knowledge in an explicit manner all the time, for all of our activities.

———

Dr. Leslie Nicoll is a Maine-based author; editor-in-chief of *CIN: Computers, Informatics, Nursing*; and owner of a business, Maine Desk, LLC. She is a member of the American Academy of Nursing. After graduating from high school in 1973, she attended a generic baccalaureate program in upstate New York. She commented on the small size that fostered collaborative relationships with faculty and peers, but it was also large enough to provide excellent educational resources: "I had a wonderful education. When I think back, I think of the things that I learned there that I still use in my day-to-day work."

Nicoll commented that she knew she wanted to continue her education even in her undergraduate program. She found support for that at Russell Sage:

Russell Sage had a graduate program, not a doctoral-level program, but a master's-level graduate program. We had some interactions with graduate students to begin getting socialized to the idea of graduate education. After graduation, I moved to Baltimore. I actually had applied to and was accepted at the University of Maryland in their master's program. I took a job at Johns Hopkins Hospital, working in their neonatal intensive care, and I started taking classes part time at the University of Maryland. I had myself on the five-year plan to get a master's degree.

Then life intervened in the form of falling in love, becoming engaged and getting married, all in very short order. These changes also included a move to Chicago, something Nicoll was not particularly excited about. But it did provide the opportunity to go to school full time, allowing her to complete her master's degree in two years, not five:

I transferred from the University of Maryland to the University of Illinois. I was in their pediatric clinical nurse specialist program. When I finished, I was offered the position at University of Southern Maine (USM). My husband said, "Let's move!" We were both homesick for the East. We moved to Maine in June 1980, and I started teaching at USM, where

I stayed for three years. In the fall of 1982, I really began to look at doctoral programs. I was looking for options that didn't require a permanent move and where I could study long distance. Remember, this was before the Internet and online education! Case Western Reserve University had a doctoral program that was well established, and they were talking about having summer courses for distance study. I went there and said, "Well, you said you were going to have this" and they sort of created it for me and a few other people.

During the mid-1980s, Nicoll taught at UNH, commuted to Ohio in the summer and defended her dissertation in 1987. She was pregnant at the time, and after graduating, she took a nursing education position at what was then the Osteopathic Hospital of Maine. In this position, she felt supported by nursing administrators and was able to work on some clinical problems from a research perspective. In 1991, she accepted a position at the Muskie School of Public Service, which allowed her to devote more energy to research activities. While at Muskie, she also became editor of *Computers in Nursing* in 1995.

Dr. Nicoll is justifiably proud of the book she conceived and published in 1986, *Perspectives on Nursing Theory*. The idea for the book came to her while she was a doctoral student. At that time, library reserves didn't exist. As she said:

Imagine being handed a syllabus with ninety articles [that] needed to be read in six weeks. It seemed like we spent the first week of class photocopying articles. There had to be a better way! During class, we'd discuss one or two articles in depth, trying to figure out what the author really was saying. Of course, the professor, Rosemary Ellis, who knew everybody, always had the answer. "So-and-so was my student in 1967," she'd say, "and this is why she felt the need to write this article." My insight was that the professor presented the context in which the article was written, and that context helped to clarify its meaning. That is what made the light bulb go on for Perspectives.

She went on to tell the story of coming home for the July Fourth weekend and having friends over for a barbecue. Coincidentally, one friend, Victor, was an artist and book designer for Little, Brown in Boston. While visiting, Nicoll described her idea for *Perspectives on Nursing Theory* (she even had the title) as an anthology of articles that would include biographical information

and an author statement for every article in the book. "Basically," she said, "give readers the experience that I have with Dr. Ellis as a teacher." After the weekend, Victor pitched the idea to the acquisitions editor at Little, Brown, and within weeks, Nicoll had a contract for the book:

> *Putting the book together was an amazing amount of work. The final manuscript was over two thousand pages and filled five boxes, and I did this in a year. I asked Rosemary Ellis to write the foreword. She was very skeptical, saying: "If you bring me the manuscript, I will look at it, and I will let you know if I will write a foreword for you." Eventually, she did agree to write the foreword, telling me it was a wonderful book when she was done. I was very proud of her contribution. It was one of the last things she wrote and had published, as she died about a year later.*

When asked if she had any advice for young nurses pursuing graduate education, Nicoll said:

> *Don't wait for years to go back to school. I think the adage of having "many years of clinical experience before entering graduate school" is bad advice. Getting a doctorate is very hard; it's a lot of work, but it is also very rewarding. It is an accomplishment unlike anything else. Part of the reason to get a PhD is to do the research and add to our science. That is a process [that] takes time. When I meet people who are in their PhD program at fifty-five or fifty-eight, I think to myself, "You have maybe five years before you're ready to retire. I'm proud of you for doing this, but on the other hand, we need to have people doing research to add to our knowledge through science and research. If you have just five years left in your career, it's not going to happen."*

ADVANCE PRACTICE NURSING

Loretta Ford, a public health nurse, and Dr. Henry Silver established the first certificate pediatric nurse practitioner program in 1965 to extend the role of nurses to deliver primary healthcare services for pediatric patients. Like the pediatric programs, most early nurse practitioner programs were certificate programs, and diploma nurses were eligible to become certified.[72] In Maine, the first Family Nurse Associate (FNA) Education Project was established

with grant funding for a ten-year period from the Division of Nursing, Public Health Service Department of Health and Human Service in October 1971. The FNA Project was a key component in the development of a strategy designed to improve the delivery of primary healthcare services in Maine. It wasn't until much later that the University of Maine established the Rural Family Nurse Practitioner Program with an MSN degree in 1991.[73]

In Maine, an "Act to Provide Greater Access to Health Care" was enacted in 1995 to support the Advance Practice Registered Nurse (APRN). The APRN certifications included in this bill were nurse practitioners, nurse midwives, clinical nurse specialists and nurse anesthetists. Except for certified clinical nurse specialists, APRNs worked in collaboration with physicians and other healthcare professionals. Under the provisions of this bill, certified nurse practitioners were permitted to practice independently after twenty-four months of supervised practice. This provision for independent practice allowed nurse practitioners to increase access to care in medically underserved communities. Advance practice nurses received authority to practice from the Maine State Board of Nursing.[74]

In a May 1995 article of the *Maine Nurse*, Louise Davis described advance practice nurses:

> *In the last several decades, the number of advance practice nurses has grown dramatically, until now there are over 100,000 in the United States. They are playing an increasingly important role in delivering timely, cost-effective health care, especially to populations often underserved, such as the elderly, the poor and those in rural areas. These nurses all have a post-graduate education and advanced clinical practice skills. They have passed a national certification examination. This certification must be kept current through on-going education and other professional requirements. Their standards and practices are formalized and monitored by the State Boards of Nursing.[75]*

Mary Jude was a Maine APRN who opened an independent practice. She expressed a long-held desire to assist underserved populations.

> *Growing up in Newport, Maine, back before I-95 was a reality, I understood rural Maine, and it continues to be a place where I feel most at home. Early*

on, I'd hoped to become an astrophysicist, but with the untimely death of my father at a young age from a myocardial infarction (MI), my direction changed, and I became fascinated with trying to keep people healthy!

Caring for underserved populations has always been an important part of my professional life. After graduating from the University of North Dakota's School of Medicine Family Nurse Practitioner/Physician's Assistant Program in late 1983, I began working in primary care on two tribal reservations in Maine. Thirty years have now come and gone, but the desire for addressing the health needs of those who have no voice continues to strike a chord. I would have to say that the career accomplishment I am most proud of was the co-development of a clinic for homeless individuals in Bangor with the wonderful psychiatrist Trip Gardner utilizing a fabulous integrated care model that has been copied by others across the United States.

I am somewhat of a renegade by nature; it was always my dream to develop a practice that allowed providers the freedom to work together, sharing the responsibility with the patient for their overall health. In 1997, not long after NPs [nurse practitioners] *in Maine finally gained autonomy for practice, I opened River City Healthcare in Bangor. Two friends of mine who were highly regarded women's health nurse practitioners opened a practice a couple of months ahead of mine, but I was happy to be the first FNP* [family nurse practitioner] *in private practice in Maine! Although much has changed in the last seventeen years, it has remained the high spot of my career, and most recently, I've become the medical director at a new River City Healthcare in Bangor, a nonprofit developed from the entity Cornerstone Behavioral Health.*

Although public health is my true pleasure, it's once again my pleasure to be able to provide primary care using an integrated care model that includes therapists, case managers, physical therapists, occupational therapists, pharmacists, nurses and psychiatrists to offer the very best in patient-centered care. I never plan on retiring—there's much too much to be done!

When Nate Nickerson moved to Maine from Boston with his wife in the 1990s, he left the inner city where he had been working to improve services for people who were homeless and moved to a small farm in rural Washington County. He missed the kind of work that he had been doing, however, so he moved to Portland to pursue a degree in nursing. After his graduation and

a stint as a critical care nurse, he eventually became a nurse practitioner and applied these new skills to helping build a social services safety net for Portland's growing homeless population. He explained his experiences in Portland:

> *After becoming a nurse practitioner, I looked around to see what nurse practitioner positions might be available in Portland. Among the people I talked to was the director of public health for the City of Portland at that time, Meredith Tipton. Right before the end of our conversation, she mentioned a need to help the city's growing homeless population, and I said, "Now, that's something I actually know something about. I have some background in it."*

Although the federal grant that the city had submitted to support the homeless programs was denied at that time, Nickerson was hired to organize an effort to build a public health safety net for people who needed care. In the beginning, there was literally no budget for the homeless healthcare project other than his salary. Dr. Nancy Knapp agreed to be his preceptor physician, and Nickerson began seeing patients in shelters and soup kitchens with just a backpack and a stethoscope:

> *I went to Mercy Hospital and met with their finance director and asked, "How much money would you save for one homeless person who didn't come through your ER?" Mercy had a great sense of mission to the community, and it didn't take much convincing to support this effort. That started a supportive relationship with Mercy for the whole time I was there. They really took care of the ancillary diagnostics and things for all of my patients. For two years, I worked by myself, visiting the shelters and the soup kitchens and seeing a lot of patients. We eventually got a grant that added another nurse and a couple of substance abuse counselors. Eventually, those grants grew, and services expanded to include care for HIV clients and mental health services. The Health Care for the Homeless Program eventually became the biggest community health center in the state.*

Early in the homeless program's development, Mercy Hospital's Sister Ellen Turner spent a day with Nickerson to observe firsthand the varied needs of the homeless. At the end of the day, Sister Turner asked Nickerson, "If you could have anything you wanted to help your work with the program, what would it be?"

Nickerson replied, "Well, it would be a decent place where we could see these people. You can see that I'm seeing them on desktops and in bathrooms and wherever. There's no private, dignified place to see people."

She went back to the Mercy board and came back and said: "You know, we would not only like to do that, but I also saw that people were coming to you who weren't homeless, who were just poor and didn't have access to healthcare. We would like to develop a free clinic of some kind, so if we built you a clinic, would you be willing to do both?"

Nickerson replied in the affirmative. He continued:

In celebration of their first seventy-five years in the Portland community, Mercy Hospital built the clinic that would house both the Homeless Health Program and what was then called the Portland Street Clinic. During my entire time there, Mercy Hospital was very supportive. They maintained the free clinic, the staffing and the ancillary services for all of those patients.

At some point, when it became difficult to juggle both the clinical and administrative duties, I decided that the thing I liked most about nursing and about healthcare wasn't necessarily the medical part of it. It was the social justice part of it. The thing that I found most meaningful was getting healthcare to people who otherwise wouldn't get it. I decided there were plenty of nurses to give direct care but maybe not plenty of people to run these programs. So I went in that direction and moved somewhat away from the clinical care part.

I eventually became the director of public health for the city, which introduced some additional, new possibilities. For instance, I was able to serve on the White House Committee for HIV, Advisory to the President, which was interesting. That's where some of the work about implementing the new President's Emergency Plan for AIDS Relief (PEPFAR), a landmark international program for HIV, originated. I got a bit of an inside view about how those policy things worked.

I was with the city for fifteen years. To tell you the truth, my passion is really about reaching out and creating an inclusive community [that] *is particularly focused on healthcare, prevention and public health kinds of issues, and it proved a good place to do it.*

Nickerson continued his education to receive a doctorate of public health with a concentration in international public health from Boston University School of Public Health.

At the end of the 1990s, Maine's nurses were positioned by education and experience to provide access to quality care throughout the healthcare continuum and demonstrated their contribution to cost-effective care.

CONSIDERATIONS OF QUALITY AND OUTCOME MEASUREMENTS

2000–2015

There were unprecedented changes in nursing and healthcare at the beginning of the twenty-first century. International and national events affected these changes. The attacks on the World Trade Center and the Pentagon on September 11, 2001, introduced the threat of global terrorism to our country. The United States became involved in the war in Iraq and Afghanistan. Hurricane Katrina devastated New Orleans. Nurses from Maine and around the country responded by learning emergency preparedness and traveling to areas of need. Advances in science and technology demanded new roles for nurses in specialties such as informatics and genetics. With the increase of the average age due to medical advances, a significant nursing shortage was developing. Reports by the Institute of Medicine (IOM) helped to focus the work of the healthcare system on components of quality care.[76] Quality, cost and access became increasingly established as interdependent concepts in healthcare. The following stories of nursing in the twenty-first century demonstrate the continuation of caring and compassion through one hundred years of social and technological change.

NURSING EDUCATION

Nursing research had an impact on nursing practice through developing new curriculum and preparing students to assume new responsibilities in caring for patients and adapting to practices in the changing world of healthcare. *The Future of Nursing: Leading Change, Advancing Health*, the first IOM report dedicated specifically to nursing, was published in 2011. This report underscored the legitimacy and value of the nursing profession's role in health policy and in improving healthcare for Americans. The role of advance practice nurses received the support of this influential and interdisciplinary body, and the recommendation that entry into nursing practice be at the baccalaureate level was encouraged.[77] In 2010, the Carnegie Foundation for the Advancement of Teaching published *Educating Nurses: A Call for Radical Transformation*. The Carnegie Foundation's research stressed the importance of education focused on intellectual development, clinical judgment, ethical comportment and mentorship into the profession.[78]

ANA-Maine president Irene Eaton, vice-president Patricia Boston and Juliana L'Heureux with state representative Hanna Pingree. *Courtesy of Juliana L'Heureux.*

A nursing Honor Society induction. *Courtesy of Juliana L'Heureux.*

Nursing education began to partner closely with hospitals to address entry into practice issues. All nursing programs in Maine came together as a group to thoughtfully address the nursing shortage and to facilitate educational mobility for nurses and students.

In 2010, the Bingham Partners, in collaboration with OMNE, the Betterment Fund and One Maine Health, were awarded a Robert Wood Johnson Partner Investing in Nursing's Future (PIN) grant. The purpose of the grant was to "re-design nursing education to create appropriate nursing professionals to meet the needs of the people of Maine, with a specific focus on long-term care and home care serving urban and rural seniors." This partnership between educational and service-oriented institutions offered many benefits for nurses and healthcare. It encouraged the sharing of ideas and concerns, identified common goals and developed core competencies that were adopted by all Maine nursing schools.

Therefore, the Maine Nursing Educational Collaborative (MENEC), made up of chairs/directors and other faculty representatives from the fourteen schools of nursing, was formed. This group looked at ways to promote the transfer of credits, to increase mobility between nursing

Lisa Harvy-McPherson and Susan Sepples. *Courtesy of Juliana L'Heureux.*

programs and to meet the IOM's goal of having 80 percent of nurses educated at the baccalaureate level or higher by 2020. Moreover, the Maine State Nursing Action Coalition (MeNAC) became a part of the Robert Wood Johnson Foundation's (RWJF) Future of Nursing State Implementation Program (SIP) and received a two-year grant of $150,000. The national coalition received $7.65 million; this combined initiative would prepare the nursing profession to address our nation's most pressing healthcare challenges: access, quality and cost.[79] Working together, Maine nurses began to address long-standing problems and plan for the future.

INFLUENCES OF WAR

The human cost of war in Iraq served as a catalyst for advances in medical and nursing care. Cogent examples included the care and rehabilitation of traumatic amputations and the development of prostheses, advances in wound care and treatment of posttraumatic stress disorder (PTSD). War, again, offered another legacy to the profession: that of producing committed, caring and highly skilled nurses.

As a high school student, Andrew Wasowski had not considered becoming a nurse. He graduated at the age of seventeen and was approached by the U.S. Marine Corps. He scored well on the aptitude testing and signed up for a five-year active duty commitment as an intelligence analyst. It was during his third tour of duty in Iraq that he met a Special Forces medic who took him under his wing and introduced him to the world of medicine. Wasowski remembered:

> *I was based at Al Asad for my second tour. Then we went to Fallujah. In October 2004, we were calling Fallujah the biggest offensive for the Marine Corps since the Tet Offensive in Vietnam. That was pretty intense fighting, house to house, block by block. We had several different MASH-like units, and we saw a lot of wounded. But the information that they had given us was just really basic: "OK, if an arm gets blown off, put a tourniquet on it. Sucking chest wound, put a plastic bag over it." No higher-level thinking other than, "OK, if it's leaking, stop it. If they can't breathe, clear the airway."*

Wasowski decided he wanted to enter nursing school immediately after being released from duty. He worked for a year on the night shift in a substance abuse treatment setting after graduation. Without a physician present, and being the only nurse scheduled at night, Wasowski learned to think on his feet. His work with people withdrawing from opiates and benzodiazepines served him well when he later found his niche on a cancer treatment unit. He had a greater understanding of alternative ways to treat pain and of the synergistic effects of medications. Wasowski also developed self-confidence, critical thinking and the ability to use the resources available to him. He explained it this way:

When we're students, we're just trying to remember the twelve cranial nerves. Now I can walk into a patient's room and look at him, and in those thirty seconds after I get report, I can say, "You're my sickest patient, and I have to keep an eye on you." It's about being able to trust your instincts more. You still use medical knowledge and rationales. Your co-workers are a great resource; I use them every night. But the biggest change is that the gloves are off, and this person is relying on you to give them the best care that you can. And you ask, "Have I done everything that I can for this person?" It's a juggling act because things are constantly changing, and things go wrong. They really do. When it happens, there's not really anybody else to look to except you. So you make sure that you're on your A-game and do the best that you can.

In 1970, approximately 2.7 percent of registered nurses were men compared to 9.6 percent in 2011, according to the 2014 U.S. Census Records.[80] Compassionate nurses like Wasowski have done much to enrich the profession. Many have entered nursing as a second career, bringing a variety of professional and life experiences. They have offered different thinking processes and ways of approaching patient care.

HEALTH PROMOTION AND DISEASE PREVENTION

Currently, health promotion and disease prevention are concepts that are widely understood in society; however, that was not the case in the early 1970s, when Sandra Record and her husband, Dr. Burgess Record, started their careers in Maine. Early on, the Records identified the importance of health promotion, particularly for those living in poor areas of rural Maine. Their work eventually received national attention as a model of effective health promotion that has succeeded for forty years.

Sandra Record liked the sense of truly being part of a community and being able to see patients in the comfort of a familiar setting: at home, in the workplace or in a physician's office. At that time, the only public health department in Maine was in Portland. Record introduced a new, comprehensive approach to wellness in Franklin County, Maine:

I took prevention to the community. In community health, you go to where the people are. I worked with others to help achieve a healthy heart

community in which health behaviors are the norm; cardiovascular risk factors are identified and managed appropriately; disease prevention and wellness are highly regarded; human and financial resources are used efficiently and effectively; and geographic, financial and socioeconomic barriers are overcome.

Record viewed the time she spent with individuals focusing on risk factor identification, counseling and follow-up to be some of the most significant experiences of her career. Her experiences exemplified her values of holism, patient-centered care and health promotion throughout her patients' life spans. Record and her husband were committed to promoting the health of rural populations while at the same time controlling costs. Armed with blood pressure cuffs, compassion and knowledge of health promotion strategies, they assessed and counseled people where they were located; these locations included grocery stores, businesses and county fairs. They later received the support of the medical staff at Franklin Memorial Hospital and founded the Franklin Cardiovascular Health Program in 1974. It focused on controlling and treating high blood pressure. A cholesterol program was added in 1986 and smoking prevention/cessation programs in 1988, and in 1998, all programs were incorporated into the Western Center for Heart Health.

Rural location and poverty are significant risk factors for poor health. Franklin County is among the poorest in Maine; however, over the forty years that the Records provided leadership and championed health promotion efforts, the county achieved a statistical improvement in health status and significant cost savings to individuals and communities.

Bettie Kettell, environmental health advocate. *Courtesy of Charles Kettell.*

Health Promotion Project, SJC. *Courtesy of Elaine McCarty.*

Rumford Hospital, 2015. *Courtesy of CMMC.*

The Records demonstrated that time, supportive relationships, health information and follow-up coaching could reduce lifestyle-related risk factors. The death rate in Franklin County went from the fifth in the state to the lowest among Maine's sixteen counties. The death rate from heart disease and stroke went from just above the state average to 10.0 percent below the state average. Smoking rates dropped to the lowest in Maine: 12.8 percent compared to 24.0 percent for the state. The demonstrated success in smoking prevention and cessation influenced the state to devote most of its tobacco settlement money to health promotion.[81] As a result of their success, the Records were invited to be part of the thirty-third Bethesda Conference entitled "Preventive Cardiology: How Can We Do Better?" In 2005, the Dan Hanley Memorial Trust recognized Sandra and Burgess Record "for their courage, innovation and vision."[82]

CARE COORDINATION

Enacted in March 2010, the Affordable Care Act (ACA) examined models of care that could influence quality, cost and access. The Patient Centered Medical Home (PCMH) is a model of primary healthcare promoted by the ACA. The PCMH concept is based on patient-centered care and uses an interdisciplinary team of healthcare providers. The patient is recognized as a whole person with unique needs, values and preferences. The person is an equal partner with the provider in planning care, and where appropriate, the family members are educated about the individual's healthcare status and then learn to manage his or her care. They develop confidence in the provider, who serves as their advocate. Communication is clear and open. A second tenet of PCMH is continuity of care. People fall through the cracks during times of transition. The medical home follows the person from home to acute to chronic care or from the hospital back to the community setting. For patients with complex medical issues, the registered nurse plays a key role as care coordinator. The use of informatics and evidence-based practice are key components of the PCMH model. Other disciplines such as substance abuse counselors, mental health providers, pharmacists, physical therapists, social workers and nutritionists may be located at the facility. Health protection and promotion are championed. Increased patient satisfaction, improved clinical outcomes and decreased spending are benefits of the model.[83]

RN care coordinator Catherine Princell. *Courtesy of Blue Hill PCMH.*

Catherine Princell's early experiences prepared her for the role of care coordinator in the PCMH in Blue Hill, Maine. She had begun working in cardiac rehab and then had the opportunity to do care coordination in a cardiologist's office. She then transferred her skills to chronic disease management in a family practice office in Colorado. When she came to Maine in 2001, Blue Hill Hospital was in the midst of writing a grant for embedded care coordination and chronic disease management. Princell's expertise fit well, and when the grant was awarded, she was given the position. She summarized her experience:

I worked with patients with one or more chronic diseases. I ensured that their treatment was current and that they followed their medical plan and educated them about how to exercise, eat right, test their blood sugars or weigh themselves daily if they had heart failure. The goal at that time was to keep people from becoming high risk and to avoid complications or hospitalization.

With the introduction of the accountable care organization and patient-centered medical home, a goal was identified to reduce waste by keeping people from using the emergency room inappropriately and from being readmitted to the hospital unnecessarily. We started looking at another population then, the frequent fliers in the ER, and calling and connecting with them to see why they went to the emergency room instead of calling the doctor's office. We looked at strict post-hospital discharge follow-up for patients so that they weren't readmitted unnecessarily. The cause of readmission was often medication management and lack of follow-up with primary care providers.

The care coordination model has evolved into high-risk, stratified patient management. Chronic disease management occurs at different levels because the populations are so big and so different. The care coordinators work more with the high-risk population than the chronic disease population. Health coaches, social workers and community-based teams work specifically with patients who have chronic diseases, both in accountable care and in patient-centered medical homes.

Accountable care looks at delivering care in the right place and the right time in order to keep people healthy. Consequently, the cost to the insurance carrier, particularly Medicare, is reduced by making sure that no one falls through the cracks related to the services, the testing or the follow-up care that they need. We're looking at very specific clinical parameters, and we have to meet certain guidelines related to those parameters. If we have patients that are not meeting those, the family practice offices are tasked with contacting those patients, making sure they get the testing they need and looking at follow-up care such as referrals to nutritional counseling, behavioral health support or specialist care. We are an accountable care organization (ACO) under Eastern Maine Health Systems, which was chosen to be a part of this pilot by Medicare. It is looking at setting standards of practice across their entire system related to these clinical parameters. We look at outcomes constantly.

The patient-centered medical home coordinates all the care for that patient out of the family practice office. It's the central location of care. More offices are bringing nurses in to coordinate that care, and the cost is absorbed into the cost of the practice at no charge to the patient or insurance company. The chronic disease management that I've been doing for years is a billable service. I see patients in between their physician visits, either monthly as needed or on a quarterly basis. Having a dedicated person who can spend the time it takes and has the clinical experience to provide self-directed care within evidence-based guideline parameters supports the PCMH concept, as well as the cost containment goal of the ACO. I think there's going to be more RN involvement in the outpatient venue than ever before as we move forward with the changes in our healthcare system.

EVIDENCE-BASED PRACTICE

Advances in medicine and nursing science demonstrated that trial and error and tradition were not enough to ensure quality patient care; there was a need

A neonatal intensive care unit, 2005. *Courtesy of CMMC.*

to apply emerging research as a way to improve clinical practice. A significant time lag existed between the completion of research studies, publication and the application of findings in the practice setting. Clinical nurses often did not understand the importance of evidence-based practice or how to search for and evaluate scientific information that could be applied to their day-to-day practice. Alyce Schultz wanted to address these issues. She recognized the importance of evidence-based practice (EBP) and wanted to use this approach to promote excellence in nursing scholarship and practice.

Evidence-based practice started with having quality research done by nurses and for nurses and then bringing that research to aid the delivery of safe and effective nursing care. To do this, nurses needed to be able to access information at the point of care. They needed to know where to find the best evidence, ranging from randomized, controlled clinical trials to clinical expertise and to patient choice and values. They also had to collaborate and exchange information with other disciplines and apply that knowledge in caring for individuals, families and communities.

Schultz began her career as a nurse researcher in 1993, when she was named director of the Center for Nursing Research and Quality

Outcomes at Maine Medical Center. She was credited with being Maine's first nurse researcher, having that as the primary focus of her full-time position. During her twelve-year tenure at MMC, she promoted evidence-based practice by serving as a mentor to hundreds of nurses in Maine and throughout the nation. She helped them to appreciate the necessity for curiosity, critical observation and reflective minds. Schultz helped nurses identify high-volume, high-risk, high-frequency and high-cost problems that could be improved through research, skilled nursing and inter-professional care. She taught nurses the steps to take, from identifying problems to setting up a research proposal and conducting and publishing research. Her Clinical Scholars Program was lauded nationwide. It recognized that nurses needed caring and supportive mentors to help them develop confidence and identify themselves as clinical scholars. Her work led to clinical and academic partnerships that helped to bridge the gap between education and practice, particularly in the areas of research and evidence-based practice.

Schultz grew up on a small dairy farm in Wisconsin and graduated from a diploma program in 1964. Her first position was in an open heart surgery intensive care unit. She received her PhD in 1990 from Oregon Health Sciences University. She described how the role of a nurse researcher evolved over time:

> *I had thought for several years about the role of a nurse researcher in a hospital. I started with the idea that we needed to have a project on every unit but soon realized that there was not the same support or enthusiasm on all the units. So I began working with the nurses who were excited about being innovative leaders in changing clinical practice...*
>
> *My role as a nurse researcher was to conduct my own research and/ or mentor and lead nurses and other interdisciplinary members of our teams as the practice changes applied to the needs of patients and staff at MMC...By 2004, at least one hundred nurses at MMC had presented their integrated/synthesized literature reviews, their quality improvement and evidence-based practice projects and their clinical research results at the local, regional, national and international level.*
>
> *If my legacy is not only to have been a good mother and grandmother but also to have put Maine on the map as a place where bedside nurses conduct and are known for their outstanding clinical research that improves the outcome for our patients, I will have achieved SUCCESS!*

Schultz exemplified the range and breadth of contributions that nurses could achieve. She has received numerous research grants and authored over thirty peer-reviewed articles. She has been recognized by many professional nursing groups and was inducted into the American Academy of Nursing for her mentoring of clinical nurses in research and evidence-based practice and development of the clinical scholar model. In 2010, Schultz was selected as a Fulbright Senior Specialist.

INFORMATICS

Continuity of care and care coordination is facilitated by the use of informatics and electronic medical records (EMR). Susan Cullen, manager of clinical informatics for Eastern Maine Health Care System, provided some insights into the benefits and challenges of healthcare technology:

It's all about patient safety. A good EMR will promote the benefits of clear and concise documentation by guiding nurses in decision-making processes. It also provides a wealth of electronic resources that relate to topics such as disease processes, medication information and discharge education. A significant decrease in medication errors has been noted with the use of bar code scanning, an application that will soon be applied to blood administration and other high error–prone treatments.

Health information technology will also better define nurses as professionals, as they will no longer be responsible for performing tasks for physicians. Providers are now responsible for their own orders, with verbal orders used only in emergency situations. They can access the EMR from any venue, on any device, so there is no reason a nurse should enter orders. Providers will also be responsible for performing their own medication reconciliation, a practice that is within the provider role, but in the past, nurses have always completed this important process. The process of admission assessment is currently under scrutiny. Historically, nurses perform the written/documented assessment, just to have the provider ask the same questions several minutes later, which is an aggravation for every patient. In a recent survey at EMMC concerning this topic, it was disclosed by many RNs that providers do not even review the nursing admission assessment but prefer to rely on their own documentation. In the near future, documentation will be more dynamic, and entries will

A nurse and patient, 2005. *Courtesy of CMMC.*

populate from all specific areas of the EMR and be more evident to those investigating data. The use of tools such as mPages, nursing hand-off and communication pages will provide more upfront insight into patients' statuses so that care providers do not have to search through myriad electronic pages to find vital information.

Despite the benefits of the electronic health record, it also creates challenges for nurses and nursing care. Cullen summarized these as follows:

The greatest challenge we hear from the end user is that documentation in the EMR takes away time from patient care. There is no denying that point; it does. We always tell our students, "We never said that the computer was going to make the process faster. It makes the care we provide safer." Another factor is that often people rely too much on computers and feel that it will provide all the answers, so they don't need to think as hard. The computer is only as good as the person who is operating it; it is not a replacement for one's brain. Some believe that it is an intuitive machine—and it is, to a point. It is as intuitive as we build it to be with all of its rules and alerts, but it is not a replacement for good, human common sense. It is not going to fill in the spaces a nurse leaves empty, and we cannot build rules and alerts for everything. People who are subjected to many warnings develop what we call "alert fatigue" and end up ignoring the flashing of the alerts that were built to protect patients. Nurses must rely on their brains and use the computer as an adjunct to good judgment. In the near future, documentation will be more dynamic, and charting will get faster with every upgrade. With more standardization and less customization built into our technology, documentation will become clearer and patient safety more attainable.

Technology does not necessarily ensure safety, and many nurses feel that it takes them away from patient care. Cullen continued:

One of the biggest challenges is how to keep up with the ever-increasing changes in healthcare technology. Currently, we deliver so much information and mandatory education to our care providers that they have a difficult time navigating through it. This takes away from the time they need to spend with their patient providing that human interface. This new technology also creates another dilemma: who is going to ensure a nurse's competency in using the EMR? In the middle of all of this is the nurse. When does the use of technology outweigh bedside time with patients? We do not want to lose our humanness with either our patients or our healthcare team. We need to keep these things in mind as new technology rolls out faster and faster.

As the level of patient acuity increased and lengths of stays in hospitals became shorter, nursing schools had an obligation to ensure that students were prepared to provide safe care to very sick patients. One way to accomplish this was to allow students to simulate patient care experiences in the controlled setting of the laboratory before assuming care in the

hospital. Simulation can promote clinical reasoning and critical thinking, which are essential skills for nurses. Simulation can ensure that all students are exposed to frequent and important patient problems and the related care.

———

In her oral history, Janice Childs recounted her role in developing the nursing learning resource center and, later, the simulation center at the University of Southern Maine (USM). When she came to Maine, she applied for a faculty position at USM, but there was no opening; however, a staff position soon opened in USM's nursing learning resource center (LRC). Childs had been working in an LRC on a grant to create an intensive care simulation center. She applied for USM's position under the condition that it would become a faculty position. Childs came, and in a few months, the position was converted to a faculty line as promised. Childs explained her previous experiences at the University of Maryland with developing simulation as a teaching tool:

> *My involvement with the learning resource center grew to include events and organizations nationally. We saw simulation being talked about more. The airlines had used simulation forever. It was coming into healthcare, and we knew it was coming to our place. We became very involved and interested in it. There was a small group of us who loved it. I love playing with computers, and they don't intimidate me. Those folks who were interested in computers and in learning resource centers developed this interest in simulation and high-fidelity mannequins—the mannequins that breathe and talk and have pulses and heart sounds and lung sounds. This small group of faculty decided simulation was the way. Six of us formed an organization: the International Nursing Association of Clinical Simulation and Learning (INACSL). We have exploded. We now have two thousand members. I'm going to come to tears because who knew in 2001 that we would create such an organization. There were five of us out of the University of Maryland.*
>
> *Simulation has been wonderful, and it's only going further. It's still young, and people are learning how to use it. INACSL just created the standards for simulation, and they're being used internationally. I had the good fortune of working on that as well.*

The newest model is the closest you can get to real people. Sim Man is still a plastic mannequin, but he weighs sixty pounds, so he's heavier. He's not like the ones that you pick up and they fly around. The articulation of his joints is a little different. You can actually move his joints and do range of motion. With the technology and the connection to the computer, he's got heart sounds, lung sounds and bowel sounds. You can start an IV. You can draw blood. He has pulses, pedal pulses up to his carotid pulse. His eyes blink. You can intubate him. You can pass nasogastric (NG) tubes. You can instill things in his ears, his nose and his eyes. He bleeds, he sweats and he talks. And you know what? It's the talking that seems to really draw students in. They initially are uncomfortable and giggly. When you're in the control room and you say something, it draws their attention to the mannequin and he becomes real. I don't know why, but I love it. I love being in the control room and watching them be uncomfortable and not know what to do. Then I talk for the mannequin, and the whole thing changes.

We've had to realize that with some faculty, it is a slower process because it's the big "c" word: change. They have been doing it the same way for a long time, and it takes a while to make those changes. And it is technology. It's computers. It seems too surreal, too involved. They're afraid they're going to break it.

The students, for the most part, love it. They want more. We're doing lots of research. The hardest of the whole thing is the critical thinking that occurs. But students love it. Intuitively, we know that this experience prepares them better for clinicals. You have to see a student before and a student after. There are many things you can do in simulation that have positive outcomes and that they can take to clinicals rather than having negative experiences in clinicals with a real person.

Lifeflight Nursing

Like many nurses, Carol Jordan's career trajectory followed paths that she never anticipated. When she started the diploma nursing program at Eastern Maine General Hospital in 1964, Jordan never imagined that she would become a Lifeflight nurse. This is her description of the achievements she made:

A helicopter transport. *Courtesy of CMMC.*

Emergency room nurses, 2013. *Courtesy of CMMC.*

I used to go to schools, and I told the kids, "When I became a nurse, never did I envision that my beautiful white cap would be an $800 Gentex helmet; nor my white uniform would be a green suit that was horrible, hot and ugly looking; and my white clinic shoes that I waited to get all through nursing school would be steel-toed black boots. You have the opportunity in nursing to do and be whatever you want to be."

Upon graduation, Jordan planned to stay in a hospital-based critical care setting. Then came a shift in healthcare delivery. Medical care became increasingly complex and specialized. Small hospitals could not provide the full range of services offered at larger hospitals. This was a particular concern in meeting the needs of acute critical care and trauma patients. There was a plan for developing a transport service. Because of her years of clinical experience, expertise and personal characteristics, Jordan was called on to become part of a new movement in medical and nursing care. She remembered:

In 1997, I was on the day shift, and we had started working twelve-hour shifts. There was a plan for developing a transport service. I was asked, along with a couple of other intensive care nurses, if we would consider it. I thought it would be a great opportunity. I could take my intensive care love outside of the hospital, put it in an ambulance and bring the patient back to the hospital with a sophisticated team of nurses and paramedics.

It was a huge amount of training to go through. We had special protocols to treat patients, give medications, ventilate patients, intubate patients—all of those things that are out of the scope of a bedside nurse. Six months after we started that training, there came an opportunity for a helicopter to come to the state, to EMMC and Central Maine Medical Center in Lewiston. We were asked if we would like to fly and be a ground-air team. I was scared to death to fly. All of us had to truly think about it and go home and talk to our folks. My family was extremely supportive. At the time, there were eight nurses and eight paramedics hired for the ground and air transport program.

There was an exhaustive training for the better part of the first year. I had to do things that I never thought I would ever have to do as a nurse: learn the whole emergency medical side of things, become a nurse that would operate out of the back of an ambulance, go to a scene and do things that bedside nurses don't do. We had to go to training in Groton, Connecticut, for a dunk tank experience, which is to learn how to get out

of an aircraft if it ever went down in the water. This was scary for me because I did not learn to swim until I was thirty years old. A lot of things were different and out of the realm of hospital nursing. What we developed from that time forward, I always equate to raising a child. We were a group of nurses who had intensive care background, a group of paramedics who were seasoned, wonderful paramedics, and we came together as a team and created something wonderful for our state. In our first year, I am not sure if we made one hundred flights or not, but that was counting ground stuff, too. When I finished in December 2009, we had made over seven hundred flights plus two hundred ground trips. We had the same eight nurses and eight paramedics as a team—never added any more crew to that.

The daily routine of a Lifeflight nurse was rigorous, even for one with an extensive background in critical care. Though outsiders often saw it as exciting and glamorous, there were parts that were time-consuming and tedious:

The first few years, flights were few and far between. We had to truly establish ourselves. We were also resource nurses. We had to have something to do so that we didn't stand around while we were waiting for a flight. We were based out of ICU. It was a great struggle because we went to ICU every morning. Our office was in the Weber Building. That's where our pilot stayed, and we had a weather-monitoring system there. The helicopter was down in the parking lot next to the river. So we'd go to do a resource task. I'd have a resource pager and a radio…While waiting for a page, I had to do a task that was short and that I could be relieved from. If I got a flight, I would call somebody and say, "You need to come to 407; I've got a flight." One of the other nurses that I worked with would come. I would run downstairs; run across the parking lot; go up to the Weber Building; change my clothes; get blood from the blood bank; get a whole host of drugs, narcotics, intubation meds; and then run and get in the aircraft in under twelve minutes. That still persists today. Lifeflight nurses have to be in shape. There is a weight requirement, and all of us had to pass the physical fitness agility test every year…My busiest day, I think, was when I had six flights in one day. It was in the middle of the summer. It was very, very hot. Those suits are flame retardant, so they are very hot. And you have to wear all of the stuff.

The part of it for me and for my peers that was so important was that we were giving the patient the best shot, the best chance at survival, and that was getting them to the facility where they needed to be with an experienced

flight critical care team in the back of that ambulance or in the back of the helicopter. I was proud to be part of that, and I will have that with me forever. I am proud of what I have been able to do and proud to help with this accomplishment in my profession.

PALLIATIVE CARE

Jackie Fournier saw many changes transpire over her thirty-five years in nursing. One experience that had the greatest impact on her was being part of a model of care that focused on quality of life. Fournier graduated from a diploma program at Saint Mary's Hospital in Lewiston, Maine. She continued her education at Westbrook College, receiving a bachelor's degree in nursing. Later, she went to Boston College for a master's degree as a clinical nurse specialist and earned a postgraduate degree as an adult nurse practitioner. She fondly remembered the history of Maine's hospice and palliative care movement in this way:

Kennebec Valley Regional Health Agency, now part of MaineGeneral Health Care System, approached nurses and asked, "Would anyone be interested in participating in a new program called hospice care?"

I was one of five nurses who volunteered for this innovative approach to patient and family care. The remarkable thing was that all five of us came from critical care backgrounds, probably because we had seen patients and families struggling through the decision-making process involved with critical illness. The approach of critical care was always about doing procedures and life-extending measures that did not necessarily add to quality of life.

One basic tenet of hospice is collaboration with other healthcare providers. This meant creating a framework where interdisciplinary teams worked together toward a common goal in caring for the patient and family. Initially, there was a transition in clarifying roles and appreciating how each discipline approached patient care with its own unique perspective. Now, it is a natural part of quality patient care. Being part of a brand-new program in healthcare was incredible. It was exciting to be part of a solution. The energy created during that time laid the firm foundation for what hospice care was to become in Maine.

With hospice for patients with an anticipated life of less than six months, another innovative program emerged called palliative care, with specialized medical care for people with serious illness. Palliative care provides another layer of support when a patient seeks care all the way through the progression of chronic disease to end of life. Nurses assist with clarifying the individual's goals of care, code status and symptom management. Palliative care affects quality of life through easing symptoms—pain, nausea, constipation or the stress of the illness—whatever the diagnosis. The ultimate goal is the patient's control of his individual situation. Palliative care is there to enhance and improve quality of life for both the patient and family.

This program cannot be successful unless it is done by a team of dedicated experts in palliative care. I have been working at Central Maine Medical Center for the last five and a half years, since the inception of a patient palliative care consult service. The service is strong, with the support of three nurse practitioners, four physicians, a licensed clinical social worker and a pastoral caregiver who consults as needed. Our program has grown from 200 consults to over 650 consults a year. We partner with all specialists and the teams that care for the patients on the medical-surgical floors. In ICU, there is resounding support for the extra care critically ill patients receive with palliative care. When nurses do their daily rounds, the question put forth for each patient is: "When should Palliative Care see the patient or meet the family?" Some of the triggers for referral include people with multiple admissions, end-stage disease, pain and symptom management, traumatic injury or illness refractory to treatment.

Palliative care is often asked to be a conduit to crucial conversations with patients and families. We work closely to clarify any information that is confusing, frightening or overwhelming. An example is a ninety-five-year-old person with an ICD [implantable cardiac defibrillator]. What does that mean to have it deactivated or keep it activated? Does the patient have an advanced directive? What would he want given the seriousness of his illness and no chance for healthy recovery?

I am fortunate to have worked in dedicated teams throughout my nursing career, whether that was in the Emergency Department, being an assistant faculty member at University of Maine at Augusta or with the inception of a hospice program or palliative care. I am not a silo. I never have been. I do my best patient care within a team. These are things that really influenced who I am as a nurse.

COMPLEMENTARY THERAPIES

The term "integrative medicine" denotes the true integration of a variety of approaches within mainstream medicine in order to support optimal wellness. Alternative approaches are those used instead of mainstream medicine, while complementary approaches are used in addition to or as an adjunct to traditional medicine. In recent years, nursing research and the demand for evidence-based practice have strengthened knowledge about and the credibility of these approaches. Integrative medicine is now introduced in undergraduate nursing programs and is supported through organizations such as the American Holistic Nurses Association (AHNA) and government agencies such as the National Center for Complementary and Alternative Medicine (NCCAM).

The oral history of Bettie Jayne Frosch illustrates how one nurse came to appreciate the healing power of humor and used this approach throughout her career. Her story began at a nursing conference. She had been told that she could not attend a session on humor because it was not relevant, but by chance, she had the opportunity to attend anyway:

I went into the session "Laughter and Your Funny Bone," and I absolutely loved it. It was given by a Roman Catholic nun from Kansas. Her belief was that you could use humor to promote healing. She was a dynamic speaker. I came back to my workplace and said, "I want to share with you what I learned at this workshop."

We used to have monthly meetings with all of the staff, not just the nursing staff, but housekeeping, maintenance, everybody. I was invited to give a presentation. I told a few jokes, and I shared everything that the nun had given us. I didn't know when I started whether this was something that would reach all levels. The executive director of the facility was there. We had the doctor, the medical director, directors of nursing and housekeeping. We had a little gal from the dietary department who was hired to clean the tables. I thought to myself, "My belief is that humor can cross all those barriers, but does it or doesn't it?" It was the very first presentation I ever did, and everybody was laughing, including the little girl from the dining room. I realized right then and there that the message was appropriate for all ages and for all educational levels. That started me on a twenty-five-year path of giving lectures on health and humor. I gave them to secretaries. I gave them to nurses. I've done several at Dorothea Dix here in Maine. I did it for Saint Joseph's College for the master's degree people. I've done it

all over the state of Connecticut for singles groups. It was probably the most significant practice that I believed in 100 percent and that I could share with people, and people would get a lot out of it.

It was an eye-opener for me, that this was something that was important. It was right at the time that aromatherapy and other kinds of therapy were being introduced. I believed this was another one of those therapies that nurses could use. In my workplace, I had a humor board. I put it out in the hallway, and every week, I'd put up a different cartoon or a different inspirational saying. I also had a jar on my desk called the mood elevator. Inside were little one-liners that I used to cut out of the Reader's Digest. *When somebody would come in who was having a bad day, I'd give them a mood elevator.*

The healing power of humor was probably the most significant thing in my nursing career because I was able to take that message and share it with church groups, women's groups, men's groups. I can't even begin to tell you all the different people over the years that I've had the opportunity to share it with.

Frosch's experience was similar to that of other nurses who saw a need, believed that there were approaches outside the medical model that could enhance wellness and then worked to incorporate those approaches into practice.

NURSING AND GENETICS AND GENOMICS

The initial work on the Human Genome Project was published in April 2003. The purpose of this international effort was to sequence and map the genetic materials in the human body, as well as in other organisms that could shed light on the processes of human molecules. Genes carry the blueprint for what happens in the human body at the cellular level. All humans have a unique genetic structure. Humans' DNA sequences are 99.9 percent identical; the 0.1 percent variation causes individuality and likely influences human health, disease and longevity. It is known that diseases have a genetic component; some are influenced by a single gene and others by a complex interaction of genes. An understanding of how molecules in the human body work together gives a greater understanding of human disease and helps in prevention, diagnosis and treatment. This knowledge has the potential to

predict individual susceptibility to common illnesses and to allow informed choices about how to reduce risk. It also improves understanding of the effect of drugs on genes that affect health and illness, such as oncogenes that cause cancer, and may predict individual response to various drugs. Finally, this knowledge can help guide health promotion efforts and improve quality of life. While the mapping of the human genome holds great promise, it also raises significant ethical concerns. The public nature of the information has the potential for misunderstanding and misuse.[84]

Dale Lea was at the forefront of bringing understanding of genetics and genomics to nurses in Maine, as well as nationally and internationally. She developed a personal interest in genetics when her mother died of early onset Alzheimer's disease at the age of fifty-four. Lea described her experiences:

> *While I was working for the Maine Hemophilia Treatment Center, I learned that my mother's younger brother, an orthopedic surgeon in New York, was also diagnosed with early onset Alzheimer's disease. It was because of his diagnosis that I decided to accept a job as a genetics nurse coordinator for the Southern Maine Genetics Services at the Foundation for Blood Research in Scarborough, Maine. While working there, I studied genetics and genomics and became a board-certified genetics counselor. I worked there for twenty years providing genetic counseling and care to patients and their families.*

While Lea enjoyed the personal contact and one-on-one counseling at the treatment center, she recognized that many nurses and nurse educators did not have a clear understanding of the evolving science of genetics and genomics. She had a passion for bringing this information to nurses in a way that they could understand and apply in their clinical practice:

> *During those years working at the Foundation for Blood Research's Genetics Services, I became a member of the International Society of Nurses in Genetics (ISONG). I met two genetics nurses who worked at the National Human Genome Research Institute (NHGRI) and the National Cancer Institute at the National Institutes of Health in Washington, D.C. These nurses, Jean Jenkins and Cathleen Calzone, helped me to make some significant accomplishments in genetics, genomics and nursing. I co-wrote two books about genetics and genomics in nursing care and have since written numerous articles for nursing journals and have contributed chapters to other genetics nursing textbooks. In 2005, I was hired as a health educator*

for the Education and Community Involvement Branch and the Genomic Healthcare Branch at the NHGRI in Washington, D.C. This is one accomplishment that I am most proud of. I was able to oversee the Genetics and Rare Diseases (GARD) Information Center, which provides answers to genetic-related questions from the general public, including patients and their families, healthcare professionals and biomedical researchers.[85] Working for the Genomic Healthcare Branch allowed me to promote the effective integration of genetics and genomics discoveries into healthcare.

When my contract with the NHGRI ended in 2010, I was hired as a consultant in public health genomics for the Maine Genetics Program. I worked with my genetics nursing colleagues to develop a Maine State Genetics Plan that will serve as the foundation and guide for the integration of genetics and genomics throughout healthcare in Maine. I also met with nursing faculty from all of the accredited colleges of nursing in Maine to talk about the Essentials of Genetics and Genomic Nursing: Competencies, Curricula Guidelines and Outcome Indicators, *a publication of guidelines* [that] *are meant to help incorporate the genetic and genomic perspective into all nursing education and practice.*

In addition to the books, book chapters and peer-reviewed articles Lea has authored and co-authored, she has also written curriculum guides and continuing education programs. She has given numerous presentations for interdisciplinary audiences. In 2001, Dale Lea was admitted as a Fellow of the American Academy of Nursing (FAAN).

MAGNET HOSPITALS

The term "magnet hospital" originated from the observation that even in times of nursing shortages, some hospitals recruited and kept nurses like magnets.[86] The institutional behaviors that allowed this to happen were broken down into a set of standards that became known as Forces of Magnetism. Hospitals could apply for magnet status through the American Nurses Credentialing Center (ANCC) of the ANA. If a hospital demonstrated that it met the standards, magnet status was granted.[87]

The oral history of Dorothy Hill highlighted the changes that occurred in psychiatric nursing practice over a fifty-year period and how Acadia Hospital in Bangor became Maine's first magnet hospital. While in her dual position

as chief nursing officer (CNO) and chief executive officer (CEO) at Acadia Hospital, Hill reflected on her psychiatric nursing clinical experiences:

I went off to Washington Hospital Center in Washington, D.C., and did my psychiatric rotation at Saint Elizabeth's Hospital, which was the largest mental institution in the country. In those days, we did rotations three months at a time, and we went all year round to school. I ended up at Saint Elizabeth's in the 1960s in the summer, when it was hot and not air conditioned. I was fascinated with why people were at that hospital; what was wrong with them; why they were still there, as many of them had lived there all their lives. I got totally involved in wanting to know more about the brain. After the rotation, it was clear to me that that is what I wanted to do. When I graduated, I had my first job at Saint Elizabeth's and stayed there for several years until I had children and moved to Maine. I have never done anything but psychiatric nursing. I don't think there is any place we go where there isn't an opportunity to practice what psychiatric nursing really is. It's certainly been the love of my life in terms of what I do or have done with my career and what my desire is to do something for other people.

Hill moved to Maine and soon was hired at a new private psychiatric hospital. It was her first experience of working on a multidisciplinary team. There was psychology, social work, nursing and a psychiatrist. She found satisfaction in learning about multidisciplinary team care. Hill spoke of previous experiences in mental healthcare:

Once people began to look at what was going on structurally in people's brains who were mentally ill, the whole field changed. That was an enlightening time in moving away from people believing that it was the mother's fault if you were mentally ill, which certainly was the prevailing wisdom at the time that I began my career in nursing school. There was a lot of talk about schizophrenogenic mothers; a lot of blame to families; a lot of sadness around all of that for those of us who didn't understand what was wrong. I didn't feel that blaming other people was the way to go. People who go into this business really wanted to look at the whole person and look at reasons for behavior. Broadening that scope of reasons was this notion that it's biological, and genetic, and environmental and things that we don't even know about yet. For me, that period of time, in that decade of beginning to really understand, made so much sense. We are still adding to our knowledge base about how the brain works and doesn't work.

Hill noted that psychiatric settings were known in the past to be everything from punitive to uninvolved. In some institutions, the nurse was expected to have only superficial communication with patients and talk about things like the weather. The psychiatrist was the only person to talk to people about anything that was therapeutic or personal. Hill realized that psychiatric nursing couldn't be done when people were saying that you can't be involved other than in a superficial way. She knew that was not the way she wanted to practice.

Later, in her role as chief nursing officer at Acadia Hospital, Hill suggested the idea of applying for magnet designation at a time when magnet status was just beginning to be understood as a significant recognition for hospitals. Magnet was a voluntary program with the primary goal of recognizing nursing excellence in the areas of patient care, innovation, visionary nursing leadership, support for professional nursing practice and positive patient outcomes. It also served as a vehicle for the dissemination of successful nursing practices. In 2003, Acadia became the first hospital in Maine and the first freestanding psychiatric hospital in the world to receive magnet designation from the ANCC. Hill recalled the path to achieving this goal:

I went to the University of Washington for the first Magnet Conference because I was curious about what this magnet thing was. I learned that it was about excellence in patient care. I listened to the presentations at the first conference, a lot of which revolved around pressure ulcers and prevention of the same. That continues to be one of the big markers for excellence because skin integrity is something that you can see. It is something that is directly related to nurses at the bedside and to supervision of the staff. I began to wonder how I would translate some of this information to psychiatric nursing by asking, "What is excellence in care when it relates to psychiatric nursing?"

I had built this hospital with others from scratch; I knew we had built a place where we wanted to deliver the best in patient care. What was that? Why were we different? What was unique about how we deliver care here as opposed to the thirty or so years I had been in psychiatric nursing? That was the beginning of my journey of trying to figure out how to apply those ANA Standards of Practice to psychiatric nursing.

The quick answer for me was that I knew that we delivered better care here than in places I had been in the past. We had more RNs and more advance practice nurses here than in any other place I had worked. This was a deliberate and thoughtful model that I created because I knew that advance practice nurses could help educate and supervise staff nurses and

that more staff nurses at the bedside in psych was a necessity. It was a concept I started with, and I did it with a patient classification system that is based on acuity. I took some of those pieces out of the VA system that they used to measure acuity, but they never attached any staffing ratios to it. I began that process with the initial staff here to look at whether we had enough staff and then enough RNs. What should that mix look like? We found over the years that it's different on each unit. The kids had to have more tech time because they are more active; they're outside and going to do more activities. So [fewer] RN bodies could be on the unit, but that still entailed a lot of supervision of those techs. Units where people were medically ill and substance abuse units and detox units required more RN time to do complicated medical procedures. The whole premise was that you can't run units, which I was very familiar with in the government and the state hospital, with one RN for a building of people or one RN who just ran around and gave medications. There was more to excellence in psychiatric care. It came from Hildegard Peplau about the one-to-one relationship. As students, we had our one-to-ones, and we journaled on that. People knew that this was an important component of care, but when you graduated, you didn't have enough nurses to have one-to-ones with patients. The psychiatrist would drop in and write medication orders. Nurses would scramble around, getting their meds done, and you would have a host of mental health workers trying to deliver care that they were not particularly well trained to deliver. Being the only RN trying to supervise a thirty-bed locked female inpatient unit was overwhelming. Nurses were growing up in the field, then wondering always about why we're not doing things right: we don't have enough staff; we're locking people in seclusion; we're putting people in restraints; we're doing things that never felt right from the very inception. That was a common practice until it started to be exposed as poor care. Those of us who could rallied around "Well, this is going to change. Maybe the field is going to change; we want to be a part of making that change." To be a part of showcasing that change, then becoming the first psychiatric magnet in the country, has been an incredible, incredible, journey.

There was a series of things that was in our nursing philosophy, a document that has stood the test of time. It was written by Ruth Beaumont and myself when we opened the doors based on our own beliefs of what psychiatric nursing care and excellence should be. It was based on the principles of the therapeutic milieu that were written by Beverly Benfer and Pat Schroder back during my younger days about what a therapeutic milieu was and what the nurse's role was in that milieu. Those things

together are what exemplify the excellence in patient care that can only come from a place of not judging patients. If all your leadership believes in that, you have a different setting than when people are looking for consequences or for behavioral changes that sometimes people are unable to make. You start trying to get rid of words like "manipulation" and words that have connotations that behavior is deliberate in some way. All of that came together in a philosophy that makes us different and unique in terms of how we deliver nursing care—multidisciplinary care in that all the people on the team have this general sense and philosophical belief that there is a reason for human behavior that is beyond what we understand and that we can't change by punitive measures. What comes across in surveys is that "the staff cared about me; they talked to me; they involved me." Those relationship words make it a magnet hospital. Of course, along with that come all the other things that are measured in the demographic piece: the staff turnover and the nurse satisfaction. We found out from all the nursing literature that pay is not the number one driver. Nurses will come back because of the people they work with, the relationships on the units and how they can deliver care to patients.

GLOBAL HEALTH

Mobility of people throughout the world and advancements in telecommunications and digital media bring global health issues to public attention and direct attention to political and healthcare agendas. Topics that share prominence on national news include political unrest and war between nations; abuse, torture and genocide; environmental concerns such as access to clean water, famine, pollution and global warming; and the plights of refugees. Nate Nickerson is a Maine nurse who has demonstrated an outstanding commitment to global health, political agendas and healthcare concerns.

Nickerson had been working with the homeless and underserved when, in 2000, a group of healthcare professionals and business leaders in the Portland area came together with a desire to help provide sustainable healthcare to an underserved area in a developing country. Nickerson joined them in an organization, called *Konbit Sante*, that grew out of that. In his oral history, Nickerson shared his philosophy of approaching global health concerns as he described the work of this group:

Nate Nickerson (right) in Haiti with a colleague. *Courtesy of Nate Nickerson.*

The name Konbit Sante *is Haitian Creole. Haiti has historically been an agrarian society. Everybody comes together and does one person's field, and then they get together and do another person's field. The group of people getting together to help each other is a* konbit. Konbit *is a very powerful concept in Haitian culture; it includes the ideas of solidarity, equality and working together, nobody towering over someone else. It is like a traditional barn raising here; the barn is built to the specifications of the builder. The community doesn't tell someone what kind of barn they ought to build. And* sante *means health, so* Konbit Sante *is like a barn building of the health system in Haiti. I relate it to a New England barn building. If somebody needs a barn, the community comes together and chips in to help that person build it.*

The Konbit *gives the connotation that we're not coming with a big agenda. Our agenda is that our partners are successful, that they realize their hopes, dreams and goals for their health system. We're not here to tell you how to do it, but if people want to work on strengthening their health system, we'll work on it with them.*

Often people say to me, "I get that. That's the 'teach a man to fish' thing." And I say, "No, actually, it's not like that at all." That presumes,

"We know how to fish, and you don't know how to fish. So, we're going to come and teach you, and then you'll be better. If you're only more like us, then you'll be better." For me, it's more like: *"Haiti is a really hard place to fish, and you all know a lot about how things work here. We know some things, too, and together we can do a better job. We don't know all the answers here."* It's been a process of building relationships and persistence. In my opinion, the primary thing that is lacking in a lot of international work is just a touch of humility, coming not with all the answers but saying, *"Hey, we'll roll up our sleeves and work together on this."*

The relationship with our Haitian partners started in the Justinian Hospital, a three-hundred-bed public hospital in northern Haiti. And when I say "public hospital," you have to throw out what you think in the United States of what a hospital is. In fact, most shelters I worked in had more resources to work with than this hospital does. There's no drinking water for the patient. There are no linens. There's no food service. It's poorly staffed. The building was built in 1890. Having said all that, it's about building infrastructure and systems and capacities so that they're better able to care for their people. Our first efforts were connected to the hospital for obvious reasons. None of us were culturally competent to go into the community, but I think that there was a feeling that at least people with a medical background had something to contribute, for instance, about how hospitals work, how clinical care happens and how we could support them in terms of materials and equipment. After some time, we went to the director of the Ministry of Health for the northern part of the country and said, "Do you want us working elsewhere out in the community?" He directed us to a public health center that was serving a slum area outside of the city center, a poor area that had nobody helping them. We started connecting with them, and out of that grew support for their public health programs, with community health workers going out into the community that included mobile health clinics, prenatal clinics, pediatric clinics and campaigns for vaccination.

Our volunteers are not doing direct care in the hospital or the community. Our job is to enable and support Haitians to do that work. We're behind the scenes. The bottom line is that there are a number of things that need to happen in a country in order for a health system to work. They need to have an adequate and well-trained health workforce. They don't have that. We pay a lot of salaries down there for key positions that can make a difference, that are embedded in the public system, that are working either in a position to train other people or to work in the community, like community health workers.

Many workers need ongoing training. That's one area in which the volunteers with content expertise are very involved, by working with the nursing school or the resident training program at the hospital, by working with the staff there to provide more training, equipment and supplies. We've helped them develop a supply chain, and we're working with them on management systems for inventory control and on financial systems, all of which are very systems-weak. They need support in health facilities infrastructure, so we've put in two wells and a disinfection system at that hospital to improve the water distribution system.

This is a three-hundred-bed hospital. The operating budget for that hospital is very small and is not adequate, so in addition to bringing in needed resources, we try to help them do better with what they have. For instance, with their radiology department, we obtained donated equipment and installed it with the help of their technicians. We worked with their administrators to develop a business plan to manage the money so that the revenue they generated not only supported the service and could provide free care for people who couldn't pay, but would also generate some additional revenue for the hospital's other needs. It's all about working together to get them to a place where they're better able to stand on their own two feet. It's not fast work. It's painstaking, one brick at a time, but we measure the impact and believe that our partners have been proven capable, given the right supports. All our staff in Haiti are Haitian because we're also trying to build a strong Konbit Sante organization on the ground there.

Over time, we've expanded partnerships with our other Haitian health organizations and institutions. Now, in addition to two public facilities, we are working with two private ones. One is a beautiful hospital still being constructed by the Haitian Baptist Convention close to the city but outside of the city. These people have been amazing. This is one reason we've established a close relationship with them. After the 2010 earthquake, there were people who were being transported out of Port-au-Prince for care who were badly injured with crushing injuries. The one kind of patient that nobody would take were those with serious spinal cord injuries. They were either paraplegic or quadriplegic, and everybody said, "We don't have the capability to deal with them. They're just going to die, and we're going to be blamed for that." For facilities, the Baptist Convention Hospital had opened a clinic; they had just finished a maternity ward, but they had no patients in it yet. I went to them and said, "If you would be willing to take these patients, Konbit Sante will do everything we can to support you and make this successful." They readily agreed and then filled the

ward with twenty-some patients who were spinal cord injured. They did a wonderful job caring for them. I don't mean just custodial care, but they were reintegrated into the community. We then worked with them to build what is now a premier spinal cord rehabilitation center for northern Haiti.

About ten months after the 2010 earthquake, while the maternity ward was still filled with earthquake victims, a devastating cholera epidemic hit Haiti. Nickerson and *Konbit Sante* staff and volunteers worked with the large public hospital to set up a cholera treatment center in a nearby gymnasium so that the cholera patients could be kept separate from the general patient population. There was no history of cholera in Haiti, and their initial estimate was that fifteen beds might be needed for the city, so they went about putting in place the water, toilets and some of the infrastructure. *Médecins sans Frontières* (Doctors without Borders) came to help and took over the administration of the center, but in a very short time, this center proved to be inadequate as the prevalence in the city quickly grew to more than six hundred cases a day.

Nickerson continued:

I called the person from London who was the driving force behind raising the funds to get the Baptist Convention Hospital built and said, "Look, even Médecins sans Frontières *is overwhelmed with the patients in the gymnasium. You know what you did for the spinal cord injured patients in maternity? Will you do that for cholera in the pediatric ward? We'll do everything we can to support you." He and his Haitian medical director said, "Sure, we'll meet you there." After opening additional cholera beds in the hospital's pediatric ward,* Médecins sans Frontières *agreed to provide additional support and came with some heavy equipment and bulldozers and basically built a three-hundred-bed field hospital there. They gave us financial support, and we hired 120 Haitian nurses within a week to staff it. They helped us develop all the logistics—washing everybody with chlorine coming and going and the systems for dealing with the waste, et cetera.*

Once all this stuff got set up, we decided that it would not be possible to build enough cholera treatment centers unless the disease transmission slowed down. We thought that everyone would get it unless we took more preventive action. We ended up working again with those same partners and hired another hundred-some people to work in cholera early intervention stations all over the city, which provided fluids for early hydration and had

Some 1980s emergency room nurses. *Courtesy of CMMC.*

Bridgton Hospital, 2001. *Courtesy of CMMC.*

staff that taught the community how to protect themselves by chlorinating and disinfecting their water for drinking and washing their hands and had staff that could recognize how to identify people with early symptoms. Then we had to hire the Haitian version of taxis, tap-taps, to transport seriously ill people to the cholera treatment centers quickly because with this disease, time is of the essence; you have to get them hydrated before they die. This dramatically reduced both the morbidity and the mortality rate.

Konbit Sante's newest partner is a small, private health center started by a group of local Haitian volunteer doctors and nurses and serves a poor area that had no services before the health center started to organize. *Konbit Sante* has been working with volunteer architects and engineers to design this center. Proposals were just submitted to the UN and to another organization for funds to build it.

MANY OF THE RESPONSIBILITIES of nurses in the twenty-first century would have been unimagined by the nurses whose stories made up the earlier sections of this oral history; however, the caring and competence of nurses has continued throughout the years. There is continuity in how nurses eased their patients' pain and suffering, tended to their wounds of war, learned to work with developing technology, cared for patients and their families in epidemics and worked to keep people well. Through the years, nurses have struggled to develop their profession to meet the needs of society, have advocated for social justice, have demonstrated compassion and have recognized the dignity and worth of every individual. The stories in this book exemplified nurses' caring and competence from the past and into the present. These stories represent a path to the future of nursing and honor the contribution of Maine nurses to our society.

NOTES

INTRODUCTION

1. Beatrice Craig, Maxime Dageais, Lisa Ornstein and Guy Dubay, *The Land In-Between the Upper St. John Valley: Prehistory to World War I* (Gardiner, ME: Tilbury Publishers, 2009), 89. Available online at http://www.amazon.com/The-Land-Between-Valley-Prehistory/do/0884483193maine.
2. Rebecca Usher, https://www.mainememory.net/sitebuilder/site/206/page/465/detail/5481/display.
3. Juliana L'Heureux, "Juliana L'Heureux: Exhibit Highlights History of Lewiston's 'Grey Nuns,'" *Portland Press Herald*, "People" section, September 21, 2012.

CHAPTER 1

4. Ellen Davidson Baer, "Key Ideas in Nursing's First Century," *American Journal of Nursing* (May 12, 2012): 48–55.
5. Ibid., 48.
6. Lyndia Flanagan, *One Strong Voice: The Story of the American Nurses Association* (Kansas City, MO: American Nurses Association, 1976), 18.
7. Ibid., 27.
8. Ibid., 29, 30, 32, 42, 52.

9. EMMC Nursing Class of 1985, "Legacy of the Lamp, 1892–1985: 93 Years of Excellence," historical review, Eastern Maine Medical Center, p. 1.

10. Maine State Nurses Association Annual Report, June 1, 1915, Maine State Nurses Association Archive Collection, Jean Byers Sampson Papers, Jean Byers Samson for Diversity in Maine Special Collections, University of Maine Libraries.

11. Ibid.

12. "Maine State Nurses Association Curriculum Committee Meeting: May 1915," in *50ᵗʰ Anniversary Maine State Nursing Association Publication* (Augusta: Maine State Nursing Association, 1964).

13. Martha Eastman, "'All for Health for All': The Local Dynamics of Rural Public Health in Maine, 1885–1950" (PhD diss., University of Maine, 2006), 34–39. Available online at http://library.umaine.edu/thesis/pdf;EastmanMA2006.pdf.

14. Ibid., 102–14.

15. Ibid., 116.

16. Ibid., 119–20.

17. American Nurses Association website, "Expanded Historical Review of Nursing and the ANA," http://www.nursingworld.org/history.

18. Marla Davis, *Ruth Weeks Henry, RN: The Remarkable Life of a 20ᵗʰ Century Nurse* (Bath, ME: Bath Historical Society, 2008), n.97, 1.

19. Patricia B. Kernoodle, *The Red Cross Nurse in Action: 1882–1948* (New York: Harper Brothers, 1949), 162.

20. Henry W. Owen, *The Edward Clarence Plummer History of Bath* (Bath, ME: Times Company, 1936), 334.

21. Matt Byrne, "Project Calls for Mercy Hospital to Leave West End in Four Years," *Portland Press Herald*, September 3, 2014, A-8.

22. Flanagan, *One Strong Voice*, 5.

CHAPTER 2

23. Flanagan, *One Strong Voice*, 72.

24. Maine State Nurses Association (MSNA), *50ᵗʰ Anniversary Report* (Augusta, ME, 1964).

25. Harold Evans, *The American Century* (New York: Alfred A. Knopf, 1998), 22.

26. Ibid., 183.

27. Ibid., 219.

28. MSNA, *50th Anniversary Report*.

29. Flanagan, *One Strong Voice*, 79.

30. Eastman, "'All for Health for All,'" 68.

31. Ibid., 217.

32. Ibid., 217–18.

33. Flanagan, *One Strong Voice*, 81, 82.

34. Ibid., 92.

35. Ella L. Rothweiler and Jean Martin White, *The Art and Science of Nursing* (Philadelphia: F.A. Davis Co., 1938), 636, 637.

CHAPTER 3

36. Stella Goostray, *Memoirs: Half a Century in Nursing* (Boston: Nursing Archives, Boston University Mugar Memorial Library, 1969), 114–16.

37. Joan E. Lynaugh, "Toward Economic Stability," in *Legacy of Leadership*, edited by Nettie Birnbach and Sandra Lewenson (New York: National League for Nursing Press, 1993), 223–24.

38. Heather Willever and John Parascandola, "The Cadet Nurse Corps," *PHS Chronicals* 109, no. 3 (May/June 1994): 457.

39. Ibid., 456.

40. Ibid.

41. https://en.wikipedia.org/wiki/United_States_Army_Nurse_Corps.

42. Correspondence from a family member of Reitha Hodgkins Scribner to the Maine State Board of Nursing given to Susan Henderson in October 2014.

43. According to research by Dr. Elizabeth Norman, the nurses first referred to themselves as the "Battling Belles of Bataan" in 1942; the phrase "Angels of Bataan" appeared later, in 1945. Elizabeth Norman, *We Band of Angels* (New York: Random House, 2013), 53, 296.

44. *Bangor Daily News*, "Bangor Nurse Was Japanese Prisoner of War on the Philippines," May 6, 1986, 104.

45. W. Atkinson, J. Hamborsky, L. McIntyre and S. Wolf, eds. "Poliomyelitis," in *Epidemiology and Prevention of Vaccine-Preventable Diseases*, 11th ed. (Washington, D.C.: Public Health Foundation, 2009), 231–44.

46. Albert B. Sabin and L.R. Boulger, "History of Sabin Attenuated Poliovirus Oral Live Vaccine Strains," *Journal of Biological Standards* 1, no. 2 (1973): 115–18; A. Sabin, M. Ramos-Alvarez, J. Alvarez-Amezquita et al., "Live, Orally Given Poliovirus Vaccine. Effects of Rapid Mass Immunization on

Population Under Conditions of Massive Enteric Infection with Other Viruses," *JAMA* 173, no. 14 (August 6, 1960): 1,521–26.

47. Agnes Gelinas, "The Pressures, Problems and Programs of Nursing Education," address at the Proceedings of the Fifty-third Convention of the NLNE, May 1949, Cleveland, OH. NLN Publ. 1993 Mar: (14:2514), 395.

48. Valerie Hart-Smith, "The Liberal Arts and Nursing Program at the University of Maine, 1939–1956: A Study of Leadership Behaviors and the Organizational Structures" (PhD diss., University of Maine, 1994), 121.

49. Patricia T. Haase, *The Origins and the Rise of Associate Degree Nursing Education* (Durham, NC: Duke University Press, 1990), 26–27.

50. Marilyn B. Klainberg and Kathleen M. Dirschel, *Today's Nursing Leader: Managing, Succeeding, Excelling* (Sudbury, MA: Jones and Bartlett, 2010), 29–41.

51. "Proceedings of the Fifty-sixth Annual Convention of the NLNE," in *Legacy of Leadership*, edited by Nettie N. Birnbach and Sandra Lewinson (New York: National League for Nursing Press, 1993), 437–38.

CHAPTER 4

52. John F. Kennedy, "The New Frontier," address of Senator John F. Kennedy accepting the Democratic Party nomination for the presidency of the United States at Memorial Coliseum, Los Angeles, CA, July 15, 1960. Available online via Gerhard Peters and John T. Wolley, "The American Presidency Project," http://www.presidency.ucsb.edu/ws/?pid.

53. Philip A. Kalisch and Beatrice J. Kalisch, *The Advance of American Nursing* (Philadelphia: J.B. Lippincott Co., 1995), 458.

54. University of Pennsylvania, "History of Nursing Time Line: 1965," www.nursing.upenn.edu.

55. Kalisch and Kalisch, *Advance of American Nursing*, 448.

56. Dorothy L. Smith and Nancy R. Chandler, *Implementation of Two Levels of Entry into Nursing Practice in Maine: A Case Study* (Kansas City, MO: American Nurses Association, 1987), 2.

57. Jo Ann Ashley, *Hospitals, Paternalism and the Role of Nurses* (New York: Teachers College Press, 1976), 113.

58. Sar A. Levitan and Frank Gallo, "Collective Bargaining in Private Sector Professionals," *Monthly Labor Review* (September 1989): 27.

59. Anna Gilmore, *Maine State Nursing Association: 75th Anniversary Report* (Bangor: Maine State Nursing Association, 1976), 3.

60. http://www.newhopehospice.org/history.

CHAPTER 5

61. https://www.aids.gov/HIV-aids-basics/HIV-aids-101/aids-timeline.

62. http//www.cdc.gov/noidcd//dhqp/bp-universal_precautions.html.

63. Henry J. Kaiser Family Foundation, "Snapshots: How Medical Technologies Affect Medical Care Costs," March 2, 2007, http://kfforg/ health-costs/issue-brief/snapshots-how-changes-in-medical-technology-affect-health-care-costs.

64. Ilene Margolin, "Principles and Practices of Managed Care," PDF produced for MRT Behavioral Health Reform Workgroup (New York: Emblem Health, July 12, 2011), 8, 14.

65. R.R. Kulesher, "Impact of Medicare's Prospective Payment System on Hospitals, Skilled Nursing Facilities and Home Health Agencies: How the Balanced Budget Act of 1997 May Have Altered Service Patterns for Medicare Providers," *Health Care Management* 25, no. 3 (July–September 2006): 198–205, www.ncbi.nim.nih.gov/pumped/16905989.

66. Maine State Nursing Association, *Annual Report, 1960–1961* (Bangor, ME: MSNA, September 12, 1961), 6.

67. Ibid., *Annual Report: 1976* (Bangor, ME: MSNA, June 30, 1976), 45.

68. https://secure.cmmc.org/about-history-more.

69. Smith and Chandler, *Implementation of Two Levels*, 11, 12.

70. Ibid., 1.

71. Ibid., 7.

72. Loretta Lee Ford, interviewed by Beth P. Houser for *Reflections on Nursing Leadership (RNL)* 14, no. 1 (March 9, 2014), second interview.

73. "Final Report of Grant to Provide Family Nurse Associate Education in Maine," submitted to Division of Nursing, Public Health Service, Department of Health and Human Services, University of Southern Maine–Gorham, 1971, pp. 4, 5.

74. Susanne J. Phillips, "A Comprehensive Look at the Legislative Issues Affecting Advanced Nursing Practice," *Nurse Practitioner* 30, no. 1 (n.d.): 32.

75. Louise Davis, "Advance practice nursing: A Look at Four Maine Nurses," *Maine Nurse* (1995): 11.

CHAPTER 6

76. Anita Finkelman, MSN, RN, and Carole Kenner, DNS, RNC, FAAN, ANA, *Teaching IOM: Implications of the Institute of Medicine Reports for Nursing Education* (Silver Springs, MD: Nurses Books, 2007), xi.

77. Committee on the Robert Wood Johnson Foundation Initiative on the Future of Nursing, Institute of Medicine, *The Future of Nursing: Leading Change, Advancing Health* (Washington, D.C.: National Academies Press, 2011), S-3–S-10.

78. Patricia Benner, Molly Sutphen, Victoria Leonard and Lisa Day, Carnegie Foundation for the Advancement of Teaching, *Educating Nurses: A Call for Radical Transformation* (Stanford, CA: Jossey-Bass, 2010), 4–5.

79. Robert Wood Johnson Foundation News Release, "Robert Wood Johnson Foundation Announce New Initiatives to Build the 21ˢᵗ Century Nursing Workforce," August 31, 2010, www.rwjf.org/news release.

80. U.S. Census Bureau News Release, "Male Nurses Becoming More Commonplace, Census Bureau Reports (CB13-32)," February 25, 2013, https://www.census.gov/people/io/files/Men_in_Nursing_Occupations.pdf.

81. Denise Higgins, Sandra S. Record and N. Burgess Record, "Nurses Help Prevent Heart Disease in Their Community," *Bulletin: Preventive Cardiovascular Nurses Association* 6, no. 4 (n.d.): 1–5.

82. http://www.hanleyleadership.org/about-us/honoring-leadership/2005-3.

83. Susan Henderson, Catherine O. Princell and Sharon D. Martin, "The Patient-Centered Medical Home," *American Journal of Nursing* 112, no.12 (December 2012): 54.

84. National Human Genome Research Institute (NHGRI), 2012, the.nim. nih.gov/handbook/Kqp?show=all-Genetics Home Reference 4-15.

85. GARD, http://www.genome.gov/10000409.

86. http://www.nursecredentialing.org/magnet/programoverview/historyofthemagnetprogram.

87. http://www.nursecredentialing.org/ForcesofMagnetism.aspx.

INDEX

About the Authors

Valerie A. Hart, EdD, PMHCNS-BC

Dr. Hart is a professor of nursing at the University of Southern Maine in Portland, Maine, and has been a psychotherapist in private practice continuously since 1978. She teaches in the psychiatric/mental health concentration of the graduate nursing program. Her research interests are in evidence-based practice, patient-provider communications, nursing history and the role of the nurse psychotherapist. Her book *Patient-Provider Communications: Caring to Listen* (2010), published by Jones Bartlett, is the only book that specifically addresses communication skills for the advance practice nurse.

Susan Henderson, RN, BS, MA

A graduate of Saint Luke's Hospital School of Nursing in New York City, Susan Henderson received her BS from Fairleigh Dickinson University, a master's in nursing from New York University and a master's in public policy and management from the Muskie Institute of the University of Southern Maine. She taught nursing for thirty-five years at Saint Joseph's College of Maine until retiring in 2011. While a faculty member, she worked as a per diem staff nurse at local hospitals and the Cedars. She

served two terms as president of ANA-Maine and was a charter member. She was appointed by the governor to the advisory council of the Maine Quality Forum of Dirigo Health.

JULIANA L'HEUREUX, BS, MHSA, RN

Although a native of Baltimore, Maryland, Juliana L'Heureux has lived in Maine and worked in the state as a nurse for most of her professional career. As the wife of a U.S. Navy veteran, she traveled with her family and worked with humanitarian organizations like the International Red Cross, Navy Relief and military charities. When her family moved to Maine in the late 1970s, she completed her baccalaureate nursing degree at the University of Southern Maine in Portland. She earned her master's in health services administration from Saint Joseph's College in Standish, Maine. During her career, she was a home care and hospice administrator. She is also a freelance writer, and her published articles have appeared in nursing magazines and newspapers. She was the editor of the *ANA-Maine Nursing Journal* for two years. Her home is in Topsham, Maine.

ANN SOSSONG, RN, PhD, NE-BC

Dr. Sossong has practiced in the field of nursing for forty-plus years in multiple nursing roles in clinical practice and as a nurse executive, nurse researcher and educator. She is a professor of nursing at the University of Maine School of Nursing at Orono, where she has received awards for teaching excellence, including the Outstanding Teacher Award, College of Natural Sciences, Forestry and Agriculture, and several Distinguished Nursing Professor Awards from the University of Maine–Orono Student Nurses' Association and student body. She has extensive experience in instructional leadership, student mentoring and healthcare. Her service to the profession and to the community has been recognized as exemplary. She has served in leadership positions in professional organizations at the local, state and national levels, including Sigma Theta Tau International Honor Society, Omicron Xi at-Large Chapter, Maine Nursing Education

Collaborative, Maine Ethics Advisory Council, Maine College Health Association, American Heart Association and American Nurses Association. Among her many achievements was serving as a governor appointee representative on the policy advisory council and the ethics advisory board. She was instrumental in initiating collaborative efforts at the state level, including the establishment of the Maine Nursing Practice Consortium, which showcases the annual evidence-based practice conference highlighting nursing research in the state of Maine. She has presented her research at international and national nursing conferences.

Visit us at
www.historypress.net
..
This title is also available as an e-book